POSTCARDS FROM THE MOON

Mr. Brody!

Just in case you dont get around to finally this at your local bookstore (like thousands of others) Give me a ring Sometime (805) 565-1167.

Ask for Dad.

Love & xxx

cp

Postcards
from the
Moon

William
Steinkellner

JOHN DANIEL AND COMPANY, SANTA BARBARA, CALIFORNIA, 2000

Published by John Daniel and Company
A division of Daniel and Daniel, Publishers, Inc.
Post Office Box 21922
Santa Barbara, CA 93121
www.danielpublishing.com

Book and cover design: Eric Larson

LIBRARY OF CONGRESS CATALOGING-IN-PUBLICATION DATA
Steinkellner, William, (date)
 Postcards from the moon / William Steinkellner.
 p. cm.
 ISBN 1-880284-39-1 (alk. paper)
 1. Humorous stories, American. I. Title.
PS 3569.T37928 P67 2000
813'.54—dc21 99-047969

To my magic feather,

Cheri

Introduction

Twenty-two years ago, when I was twenty-two, I fell in love with a strange and funny story written on the back of a postcard. Some time later, I fell in love with the man who had written that story (for that exact reason), and the rest is our occasionally strange, often funny, history.

Since it worked so well the first time, Billy continued writing, and sending me, postcard stories. Any occasion would do—a new job, a bad haircut, the death of a neon tetra, the birth of a child. (I got one, two, and three hundred stories on the occasions of our first, second, and third labors. They got me through the early part better than an epidural, but during transition I was still a monster.)

Billy haunts postcard shows and delitiologist conventions (hardcore postcard shows), combing through decades and centuries of other people's greetings to find images that inspire. Then he comes home, sits with them, stares at them, waits for the "i" word to hit. I don't know where it comes from. It could be his mind, or his muse, but my best guess has always been the moon.

To date, his stories have had an audience of one, but it's time for me to stop being so selfish. It's time to share. So, welcome to the brain of the strange and funny man I fell in love with half my life ago. And please enjoy these postcards he wrote to me, from the moon.

—Mrs. Steinkellner

POSTCARDS FROM THE MOON

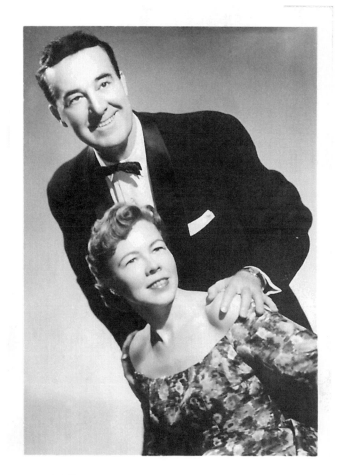

BOB McELROY & CAROL

"MR. AND MRS. ENTERTAINMENT"

Mr. & Mrs. Entertainment

"Your friends are here, Mr. Entertainment, why don't you go out there and warm them up with a few of your home-made Sazeracs and long, pointless stories about boot camp?"

"Oh, I wouldn't think of stealing your thunder, Mrs. Entertainment. Why, they'll soon be your bosom buddies once you pass out the stale bridge mix and sing the laughing aria from Leonard Bernstein's *Candide,* aka 'The Dick Cavett Theme.'"

"Oh, no, I'm sure they're just dying for twenty card tricks a twelve year old can do."

"No, no they've had a long trip. Surely they deserve to see the myriad stunts only you and your double-jointed species can perform."

"Or we could do a duet…with a little soft shoe to close."

"Oh, Mrs. E. I thought you'd never ask. I'll go get the kitchen cleanser. We'll do 'Me and My Shadow.'"

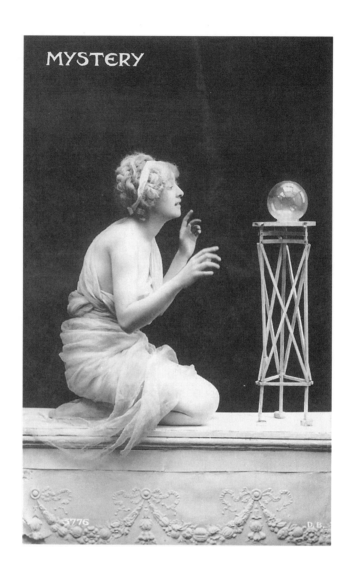

A Mystery

The crime: A hauntingly beautiful young woman is found murdered at the bottom of a steep set of stairs. She has a tiny puncture mark three inches to the left of her right eyebrow.

The clues: A handbag that exactly matches the corpse's skirt. It is empty save for an unused one-way train ticket to Athens. An antique lace shawl barely tinged with blood (hers?) found some fifty feet away in a bushy, somewhat overgrown area. A tiny canary crushed to a tenth its normal size by a powerful force of some kind (human?). A copy of *The Art of the Deal* with all references to Trump neatly cut out with a razor blade. A red golf pencil.

The detective: You. Good luck. Remember, each day the trail grows colder and the killer laughs at your dullness.

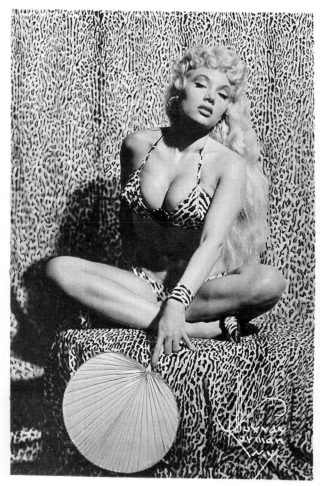

LILLY CHRISTINE

The Making of a Cat Girl

She had always been faster than the other girls. In a hurry to grow up. Trapped inside a child's body, she was always pushing, pushing, pushing. As if by sheer force of will she could age ten years and sprout womanly breasts before she was eight. Her mind got there before her body and emotions. Outside she was just a kid in jeans and worn-out gym shoes. Inside she was a sex goddess in a scarlet red outfit slashed to the legal limits both front and back on her way to accepting an Oscar with her hunky boyfriend tagging along like a lucky pup. By the time she was thirteen she had gotten into trouble. Trouble followed her. Trouble partied with her. Trouble was her best friend. She was wild, weird, and out for kicks. She burned the candle from both ends and sideways.

Then she hit the wall. One little mistake. Maybe even one made for the best reasons. Love. A mother at fourteen. And all the fun, music and boys went away. A baby had a baby. And life was a diaper. She finally slowed down. But it was too late.

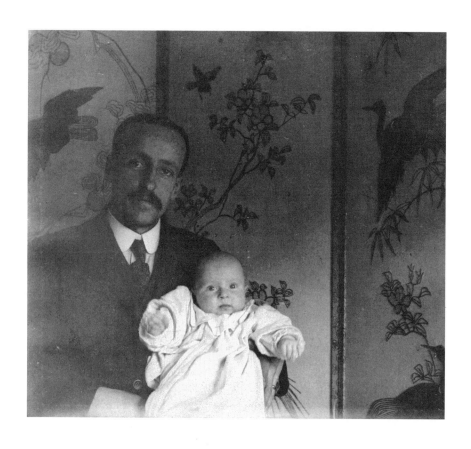

First Born

He held the whole universe in his hands. The stars, the wind and the trees. Yet she didn't seem to weigh a thing. Without the delicate wrapping around her she would just float in the air. He was in love. He hadn't loved like this since that girl in the floppy jeans.

The baby moved in his arms. The change was subtle, like the colors of the sky at sunset. But he felt it more strongly than an earthquake. When she turned her head to snuggle more firmly into the soft wool, she scrunched up her face. He felt his heart scrunch up. His heart was just an old ball of newspaper that she could toss away any time she wanted to.

She rolled again and faced him full on. Her little eyes opened. They were blue. So blue they must have been painted by a fairy. And the lashes? Ah, the lashes.

She yawned. Her lips poised as if about to say something. A tiny smacking sound, and then she fell asleep. His blood turned to tears. He sat and held her as the morning slowly became afternoon.

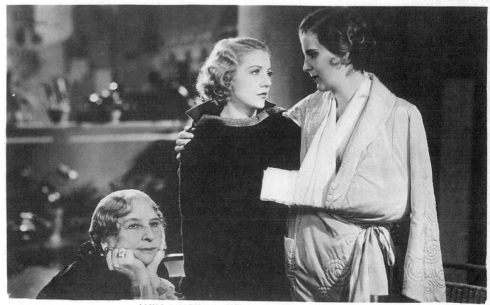

MEN MUST FIGHT *Diana Wynyard, Ruth Selwyn & May Robson.*

Biological Urges

Women must shop, bear children, decorate, get a man, buy the gifts, keep up the relationship, deal with her family, deal with his family, cook, clean, remember all important dates, make plans, keep the Rolodex current, pay the bills, feel, cry, forgive and forget, take the blame, do everything better than any man without making a point out of it, pamper their ailing spouses while running around with a much higher fever themselves, change plans at the last minute without whining, visit everyone in the world while they are in the hospital, take the phone calls that nobody wants to take, go through Herculean efforts for their loved one's fortieth birthday, and make each and every holiday extra special.

Men must play poker, disappoint women, and fight.

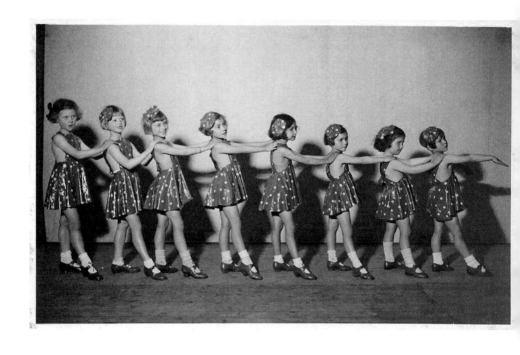

Choreographer's Notes

"All right, listen up. No talking. Stop the talking. Please stop. Let me hear only the sound of my own voice.

"You are all, without exception, terrible. You, in spite of your diminutive size, are horses. You clomp about the stage like a bunch of Clydesdales.... The big horses? Budweiser commercial? Ed McMahon? Never mind. Now, when I say I want a line with you holding the shoulders of the girl in front of you, that's exactly what I mean. The toes should be pointed out like little soldiers. Ramrod straight. Anything else is unacceptable. Perhaps if any of you had spent time in the service or military school. Well, there's nothing to be done about that now. I will just work with what I've got. I've done it before. I will spend ten hours a day working in this routine if necessary, but I will tell you what I will not do. I will not be made a fool of out there. And that's who will be Mr. Fool, believe me. They won't blame your little tushies. Oh, nooooooo, you're just children. Moppets. Tots. Kids. You don't know any better. Someone should have told them. Well, babies, if they come to pin the blame on Uncle Fritz, I won't be here. I'll be out the door, into my Rabbit convertible, and breaking the speed limit on my way to St. Malachy's and my next gig."

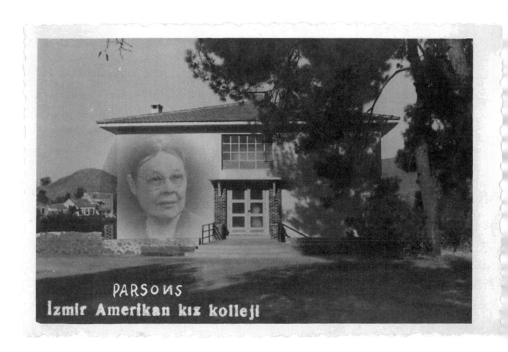

PARSONS
İzmir Amerikan kız koleji

The Disclosure

This house meets all codes. However, it is incumbent upon the seller to reveal one slight irregularity of the property. A rather substantial visage of a Ukrainian or possibly Serbo-Croatian woman occasionally appears near the front of the house. Annually these appearances number no more than eighteen and sometimes as few as twelve. The dates vary, but she always shows up on the Feast of St. Catherine and July 26, which we assume is her birthday because on that day she wears a party hat. Her visitations in no way harm the house, not even the exterior paint. The first few times the sight of her upset our dog, Cubby, but now he begins wagging his tail before she is even partially visible. Mrs. Kolleji spends her time quietly watching the neighborhood goings-on. The one time she did speak at some length she didn't reveal why she visited, but did give us an excellent recipe for apricot kolackies. End of disclosure.

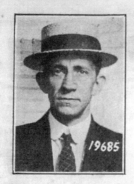

GEORGE MACGLUE

F. P. C.—$\frac{1}{1}$ U 11.
$\frac{1}{1}$ A 9.

August 6, 1925.

(Murphy on case)

$100 REWARD

For Arrest and Delivery to Officer From Here
Phoenix, Arizona, U. S. A.

WANTED -- GEORGE MACGLUE, aliases Martin K. Bostic, "Monty" Colvin. Born, Atlanta, Ga. Age 47 - 1923. 5 ft. 10½ in., 134 Lbs., eyes dark slate, hair dark chestnut, complexion Med. sallow, build, slender, occupation, Accountant, teeth, 2, lower rear re gold filled. Baltimore, Md. Police No. 19685—chg. Bigamy, dismissed. Washington, D. C. chg. Forgery, sentenced. Wanted here for Obtaining Money By Means of Forged Certified Check. Got $1800.00. Wife traveling with him, 32 to 35 yrs., 5 ft. 3 in., 135, dark hair not bobbed. Wears artificial limb and walks slight limp. Arrest George MacGlue, hold all money in his possession, and wire my expense, will extradite. WARRANT ISSUED.

J. J. McGrath,
Chief of Detectives.

GEORGE O. BRISBOIS,
Chief of Police.

Murphy's Got a Case

I gave my heart to the law once, and now I betray it. All because of Mrs. George MacGlue. Not a name you write over and over in a notebook with hearts doodled all around it, but there it is. Only two problems: she's married, and she's on the lam. It was love at first sight. I was about to pinch her little check-forging worser half when I saw her reflection in the pawn shop window. It's to laugh, but a heavenly choir hallelujahed in my heart, and cartoon cupids buzzed in my brain. I was hooked like a fifty-pound tuna. That's when she went up to him and bopped his shoulder in that aggressive, but you can see the love shining through, wifely way. My dilemma: if I arrested the little check-kiter in her presence she'd hate me. All would be lost. So I let them pass and followed until they retired to a cheap little dive that I wanted to throttle the life out of him for taking my precious angel to. I have been tailing them ever since. I have watched as she chewed gum while he bounced checks. Watched as he shoplifted string cheese and Pepsi. (She made him go back and shoplift some mascara, which he had apparently forgotten.) They run from town to village to big city. They run from the law. They run from me. All I want is for her to run to me. Hold me. Kiss me. Love me. But upon his arrest she would vanish like a dream. And so I follow. To the movies. To the bar. To the laundromat. Three lost souls in a mad dance. But only one of us knows we're dancing.

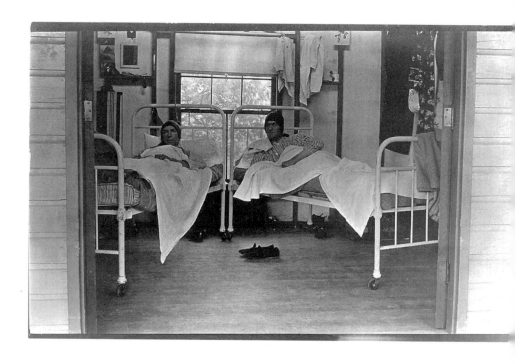

Male Bonders

"The worst thing about life here in the hospital is that you have to endure this really awful environment, and then when you finally find someone you can relate to, which makes things a lot easier, people accuse you of being gay."

"We're not gay. We're just friends. In the vernacular of the era, I suppose you'd say we're male bonding."

"Shared books and long important conversations don't make one gay."

"We made our beds adjoining so we wouldn't have to shout across the room."

"Yes. We live together, but only because we're both in the same hospital at the same time."

"Though we might when we get discharged."

"Okay, but it's not as if we've...kissed."

"Uh-oooooh. I think we might be gay."

Hail Mary

"Hail Mary, full of grace, the Lord is with thee."

"What?"

"Hail Mary, full of grace, the Lord is with thee."

"I heard you, I just don't know what you meant by that."

"I have been sent by the Creator of all things to say unto you, 'Hail Mary....'"

"Uh, please not again. The words I have committed to memory. It's the meaning that's still very foggy."

"It means that the Lord has come upon you. You now carry within you His child. The Messiah. King of Kings. Holy of Holies. Son of our Lord God on high."

"No, thank you."

"What?"

"No, thank you. I'm sure it's a very great honor, but there is a carpenter in town named Joseph. He's very nice, and if I play my cards right I could marry him. If I have the Lord's baby I can just kiss any plans I have goodbye."

"But I have been sent. You must. It's all arranged. Prophesied and everything.... You'll get your name in the Bible...."

"Okay."

The Good Boy

He ran. He jumped. He played. He liked to eat, but he
wasn't that fond of vegetables. He loved candy and cake.
(Maybe candy a little more than cake, because it was
easier to run around with.) He listened to his mother
most of the time. It was hard when you really got caught
up in playing not to ignore her voice when she yelled for
him to come to supper. But he tried. And each time
when he failed, he vowed to try harder the next time.
Which he did. He loved her so very much he would
never do anything to hurt her. But still a boy's got to do
what a boy's got to do. He loved his father, also. He saw
him as a strong tree. Sometimes when his father looked
at him it was strange. As if his dad was looking to him for
some kind of Big Answer. He did his chores (when he
remembered). He was polite to grown-ups. And good to
friends. He was gentle and kind. And very witty for his
age, without being precocious. He was friendly to a
fault, but you couldn't push him too far, because if he
believed in something it was easier to budge a rock.
All in all he was a good boy. And he couldn't wait to
grow up.

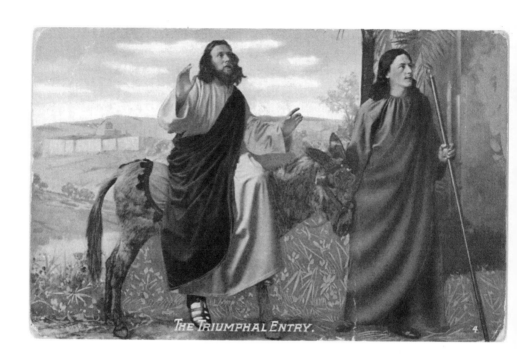

THE TRIUMPHAL ENTRY.

Triumphal Entry Scenario

"So, as I see it, first we'll have hundreds of flower girls strewing rare petals from the southern countries. Then the marching lute players, with a few glorious triumphal horns for spice. Legions, legions, legions. The mayor, the high priests, lower priests, and a host of virgins. And then you, high atop the largest elephant we can find. I think I heard that there was a real brute for rent who just did a big bash in Baghdad."

"If we must do this. And it has been prophesied. It must be simple. Like a tree or a lily. Or a dove. Or a child."

"Gotcha. So maybe tons of flowers, all shaped like various fierce animals. Elements of beauty and the beast. Hundreds of doves swooping over a huge crowd of people tugging you along the rude streets of the city. Wait, you said children, right? It's a bad time of the year to get kids, what with the High Holidays coming up and all, but I think we might be able to pull some strings...."

"I don't mean to criticize, but I think you are trying to be spectacular. You are creating a large and wondrous display to rival the very stars in the firmament. I do not want people to look at me. They should not be looking up. They should be looking within."

"So, who's bankrolling this?"

"Warner Brothers."

"Rough garments and one guy on an ass it is."

"Thank you."

Christ healing the Blind. Luigi Carracci.

Why Jesus Wouldn't Work Today

Okay, first of all you have all this healing. Leprosy, blindness, deafness, what have you. The AMA is going to be all over that like a halo on an angel. They'll probably get him on some charge like practicing medicine without a license. The FDA will be very suspicious logically assuming that He is using some kind of experimental drugs that haven't been approved yet. (I capitalized the pronoun substituting for the name Jesus, which is traditional, but if the papers had to do that there would be such an outcry about elitism and weirdness that it would probably shove all talk of his miracles right off the front page. Look at all the flack the artist formerly known as Prince took when he tried to change his name. And that was just a symbol.) When you start to have him castigating all the money lenders, probably in some symbolic display on Wall Street (maybe he'd totally hipify and do it online), well, then, you've got major problems. The banks get all huffy. Jesus can't get credit. His followers start to have trouble getting no-fee checking accounts. There is talk of disallowing the group's non-profit status. Before you know it, bing, bang, boom, the IRS has stepped in. And these are the guys who got Al Capone, so good luck, Savior. If he survives all this, there's always the tabloids. God help him then.

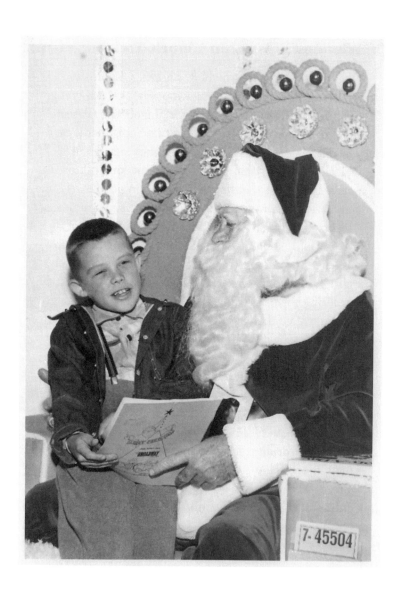

Inside

You walk in slow motion as if on some kind of drug. The paranoia is similar, too. Total strangers look at you as if you just dropped out of the sky. Some looks are friendly but guarded. Others are just mystified. How can you be walking toward them? The big hearty types gesture and laugh. Then they shake their heads and turn back again, not quite believing. The pity in many eyes is not hidden very well. The "Oh, that poor guy with a handicap, there but for the grace of God go I" face. Children scream and clutch their mothers. Some burst into tears. Unbelievably, many parents try to get them to look again and again. Some want these wailing charges to meet you! Let them be, for crying out loud. When they are on a therapist's couch, who will get the blame? Their parents? No. You.

With all this, still you move forward. Hot. Sweaty. Screamingly uncomfortable. It's hard to drive a car. It's hard to walk. Your vision is blurred. Your hearing is muffled. (Is this what old age will be like?) Everyone is staring now. You are the center of attention. You perform your simple task. The little eyes on you as if seeing one of the Jurassic Park critters come to life. More tears and fears. A shy smile here and there. Some pictures and, amazingly, a hug or two.

Then a mad waddle to the car. Tug, pull, unbuckle, and remove. The air is especially cool on your sweat-soaked T-shirt. But it feels good, like a drop of water in the desert. Like coming up for air. You are completely in the now. You feel energized. You feel very good. You are out of the Santa suit. For now.

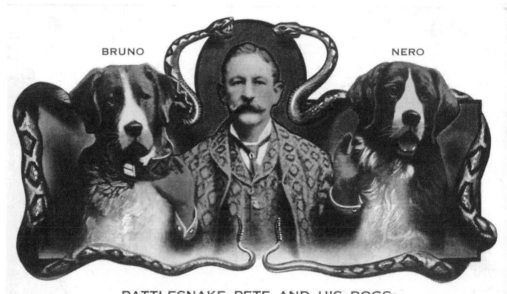

BRUNO NERO

RATTLESNAKE PETE AND HIS DOGS

8 AND 10 MILL STREET ROCHESTER, NEW YORK

Bruno and Nero

Bruno at the first sign of fleas runs to get his leash so that he can be walked far away from the critter's favorite hiding spots.

Nero has a flea infestation so bad that his family is forced to move out of state, where Dad has to take a much lower paying job. His dreams of law school fly out the window.

Bruno can sit, heel, roll over, play dead, stay, beg, and catch a Frisbee while running at full speed.

Nero...has that really bad flea infestation going for him.

Bruno once barked until someone noticed and followed him to an abandoned well, where a little girl who had fallen in was rescued.

Nero once barked until the huge next-door neighbor threatened to punch Dad's lights out, and then Bruno was quiet...for five minutes. The family tried to have Bruno's vocal chords removed, but the ASPCA sued. The judge threatened to punch Dad's lights out.

Bruno was once on the cover of *Dog World*.

Nero ripped off the covers of the March issue of *Dog World* (Leonardo Di Caprio's dog was on the cover of those copies) while he was going to the bathroom on Aisle 4. It cost dad over $355 to make good.

Bruno was named Best of Show three years running.

Nero's dad was told that he "best not show his face around here no mo'" by a drug dealer who lost $50,000 when Nero grabbed a kilo of ganja and started tearing it up. Nero's family had to live in this terrible neighborhood because his dad had lost so many jobs and spent so much time being sued.

Bruno is the best dog in the world.

Nero is everybody else's dog.

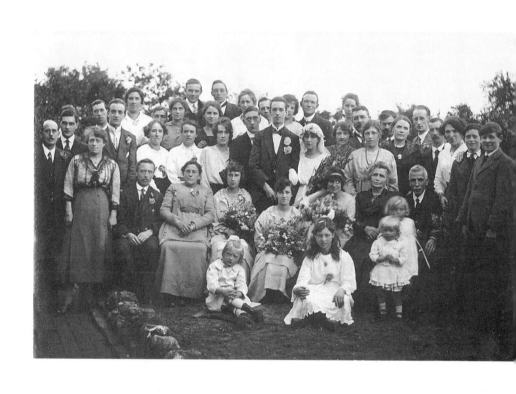

A Perfect Wedding

Except for when the groom gave too many toasts and swallowed his wedding band.

Except for the fistfight that broke out when the bride's paternal grandmother was caught going through the bridesmaids' purses.

Except for that awkward moment when the bride's father accused the minister of sleeping with his other two daughters.

Except when the candle-lit flower baskets set off the sprinkler system at the beginning of the reception.

Except when that motorcycle gang, Satan's Heroes, crashed the reception, insisting that the groom was their leader in absentia for the past five years.

Except for that terrible outbreak of food poisoning later traced to the third tier of the wedding cake.

Except for that, it went off without a hitch.

B.I.P. FACING THE MUSIC with Jose Collins

Opera Shmopera

Diantha arrives home to find her two siblings slain. She sings the mournful "Oh Great, Now My Folks Are Going To Expect Me To Call Three Times a Week and Spend Every Holiday with Them." She tenderly caresses their cheeks as their corpses grow increasingly colder. She remembers them all in happier times as she sinks into a reverie that causes her to hallucinate in tuneful flashback. The spirit of her sister, Tish, sings "You Lay One Finger on My Brush and I'll Kill You." Her brother Roland joins her for the charming duet "You Were Adopted!" Diantha, driven mad by grief, throws herself off the parapet to her death, singing "Aiiiiieee." The two siblings, who have been playing possum, arise to gleefully sing the triumphant "It Is We Who Were Adopted." End of Act One.

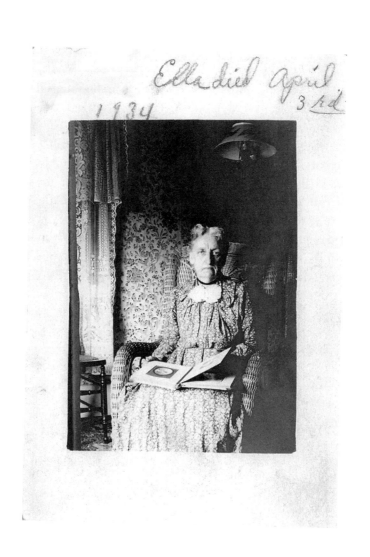

Ella died april
3rd
1934

A Significant Death

Ella died on April 3. Her passing affected the whole town, especially her neighbors and close family. She had warned them that she was near on to going, so they'd better get their affairs in order. But no one listened. They were nice to her face, but in their heads they scoffed at the idea. Many people in their hearts believe that when they die, the whole world goes with them. That is, that everything around them is created through their consciousness, so of course it would not exist without them. Their death will be the cease of existence of everyone they know. The real-life version of what happens when a famous author dies. His characters go with him. Maybe this happens all the time, or maybe it's because Ella had such a strong sense of conviction, but she was true to her word. The very second she slumped forward in her rocker and onto the floor, a force swept through the town like an invisible hurricane. People just disappeared. Her family went very quickly—bip, bip, bip. Like candles on a birthday cake. Others took various lengths of time. Some took as long as a kid opening a refrigerator to get milk. A few faded like photographs in the sun. Ella's first boyfriend, Rooster Ames, held on through four complete cycles of a traffic light. And then his truck was driverless. It got her cat, Lothario, who was under the bed at the time. They all went peacefully.

Moral: Be careful who your friends are.

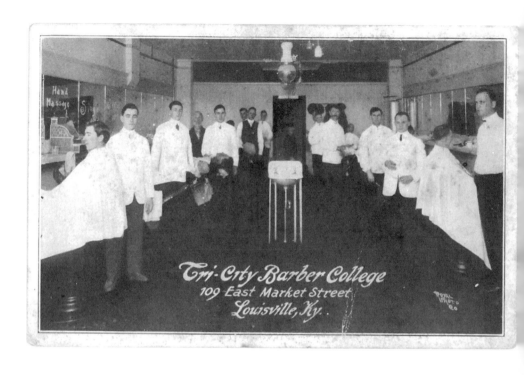

Tri-City Barber College
109 East Market Street
Louisville, Ky.

Barber College Tip Sheet

1. Upon answering a phone query, always emphasize speed (our haircuts seldom take over ten minutes, but don't promise specific in and out times; there is the occasional disaster that takes several hours to fix up again), ease (we have dozens of students waiting to take a whack at them), and, of course, price (it is a flat two dollars, no matter the cut or type of hair; there is absolutely no tipping; tipping leads to elitism, jealousy, and a ton of hurt feelings).

2. Hair is no longer to be thrown away willy-nilly. It is to be carefully sifted through under the supervision of Mr. Harold Knox and then given to Mr. Karol Knox, who will relabel it as imported female hair from Argentina and package it for use in our newly expanded wig and toupee department.

3. When someone calls and asks to speak to the "tint specialist" (as advertised in our Yellow Pages ad), do not just count to three and attempt to disguise your voice to sound like another person. Instead, hand the phone to the student next to you and have them disguise their voice. Do not hand the phone to Mitch Johannsen *ever*. We have had a long discussion with him about this, and he is only being allowed to finish out the semester by the good graces of Mr. Troy Ebersol.

4. Have fun! It's a school, not a business.

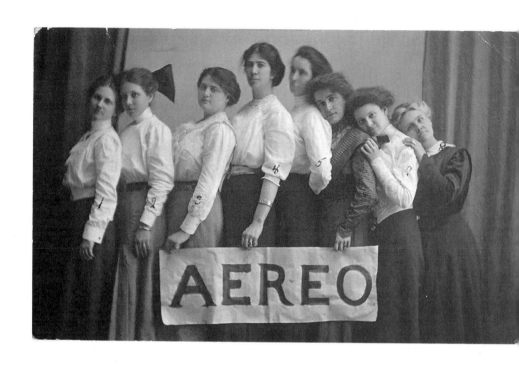

College Sisters

Edna Hill was determined that one day she would be married to the King of Siam.

Nellie Hill was the unstable one.

Ruth Sellars wanted to be the woman with the hair net who worked behind the counter in the school cafeteria.

Agnes A. would forever suffer the curse of those who are born large-boned.

Minnie Smith was obscure even to her own family. She moved away and was never heard from again except through vague rumors. Not even juicy rumors; but that, too, was Minnie.

Dulsie would lead a charmed life. She would go from one mad social whirl to the next, having the time of her life until coming to a grand realization that this could lead to a shallow existence, whereupon she married the perfect man and was happy till old and gray. No reason for it. Just nature's balance to the lives of the many who are miserable.

Mabel Roberts was often confused with Maybelle Robinson. Isn't that odd?

Georgia Cordell was really too old for this sorority, but everyone was too embarrassed to mention it.

"IT DID HAPPEN HERE" Los Angeles, Cal. Feb.20th,1944. View on South Broadway
from 12th., during Snow & Hail storm. Chamber of Commerce bldg., shown on right

50

The Mist

From an idea suggested by Kate Steinkellner

Once upon a time in California everyone woke up to a mist that covered
the land. It was as if a fine white snow hung in the air. Whiter than a
nurse's cap. Whiter than a star. None of the children could go to school.
None of their parents could go to work. You couldn't go anywhere, so
you just played indoor games with your family. Then one day, after what
seemed like a very long time (but it's very hard to judge the passage of
time during the Big Mist, as it came to be called), the mist lifted. Van-
ished, gone, vamoosed. Like a dream you wake from in the middle of the
night but can't recall in the morning. Except for one thing: the state had
been magically transformed. The air was as clean as an old 7-Up com-
mercial. The sky was as blue as a Greek myth. Everything vibrated with
an energy that made you want to work and play at the same time. It
made you as happy as a mariachi band. And it stayed that way forever.

Moral: Why let a mist do what we can do ourselves?

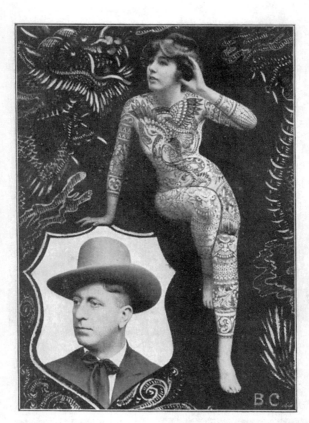

BEN CORDAY——TATTOO ARTIST

FIRST & MAIN STS., LOS ANGELES

A lifetime experience in all parts of the World including London, Suva,
Vancouver, Auckland, Sydney, Colombo, Port Said, Genoa, Algiers

A Businessman's Pledge

We promise that at Ben Corday's Tattoo Artistry Parlor
you will receive only the best in epidermal portraiture.
Our drawing tools are made of the finest Swiss steel.
They are checked daily for precision pristineness and
prophylacticity. The pigmentations have been gathered
from all parts of the globe and have never been equaled
for their authenticity to nature, clarity, and endurance.
They are guaranteed for the lifetime of the art bearer
and are money-back guaranteed to be over 99 and
$^{87}/_{100}$ths percent pure. All work will be performed by the
Maestro, Ben Corday, himself or, should he be off on an
inspection tour of one of our parlors worldwide, the
work will be done by an artist personally trained by him
from an original Corday design. Finally, contrary to
many rumors, no one has ever died of blood poisoning
from a Ben Corday needle.

As Sad

As sad as a pair of rain-drenched socks.
 As sad as a trail of train smoke leaving the station.
 As sad as ice cream on the sidewalk.
 As sad as late Sunday afternoon.
 As sad as life above a pizzeria.
 As sad as a baby with a cold.
 As sad as a hole where a permanent front tooth used to live.
 As sad as a teenager coming home three hours late.
 As sad as a lake without waves.
 As sad as a bee caught between the window and the drapes.
 As sad as a hole in your pocket.
 As sad as a smiler who never laughs.
 As sad as the fire's last whisper of smoke.
 As sad as a soul who doesn't know he has a soul.
 As sad as a love letter yellowing in an unopened box.

The Heist #1
Our Loose Cannon

Now, William E. just got caught up in his emotions. Frankly, the only reason he was involved is that he overheard the boss's plan when the boss was in stir and William E. had the adjoining cell plus an unusually sensitive type hearing ability. The guy was a forger by trade and did a little landscaping when he had to. Folks said he did an inordinate amount of talking to inanimate objects while plying either trade. So it was rather inadvisable to give him a weapon for this particular job, especially a shooting-type weapon. But the boss did, the bank guard gave William a weird look, and—*bang*—one dead guard. A professional doesn't get caught up emotionally during the job.

The Heist #2
My Raison d'Etre

Now, the whole reason for me to be involved in this whole situation was the slickness of the boss's plan. And what really hooked me was the idea of using Elmer Croft as the blind guy decoy. I have probably looked at Elmer's mug a thousand times. After all, I did share a cell with him in Polk County for near three years. (And I have to say he was an excellent cohabitator, except for a somewhat annoying habit of always whining about the universal unfairness of all other gin rummy players.) But all those times I looked into those sewer-cover gray eyes, I never saw a blind man. The boss thought of it the second he saw him. Kind of ironic that he would lose sight in that one eye as a result of the getaway.

The Heist #3
My Connection

Now, I first got involved like this. I was over to my sister's house 'cause it was so infernal hot. I got to drinking some kind of cold beers with my brother-in-law Fred. (They were fairly cold, but not icy cold like I like 'em, but they were free, which is really the best beer going.) The boss calls him up looking for a certain wheel man who, as it turns out, Fred just went to the funeral of some weeks past. But not wanting to disappoint the boss, who had helped him out of a scrape or two and who he also owed the price of a new used car to, he suggested me. It seems that he had heard a little about me, mostly good, and so he took me on. I guess you could say I got involved in this criminal activity on account of the heat.

The Heist #4
The Swell Guy

Now, I don't get involved in business with members of your darker races. This would include your Greeks, Turks, bent noses, and Negroes. It's nothing personal. It's just that they seem a little more likely to pull a knife on you when the going gets tough. Coty was a different matter. He was extremely polite, made a great mess of dinner, corn muffins in particular, and he could really chuck the old baseball, which I found out one day playing catch with him while we waited for Friday to roll around. Said he could've played for the Giants, but the majors don't like black boys. Could have something to do with that knife thing. Seems right that he was the only one who got clean away.

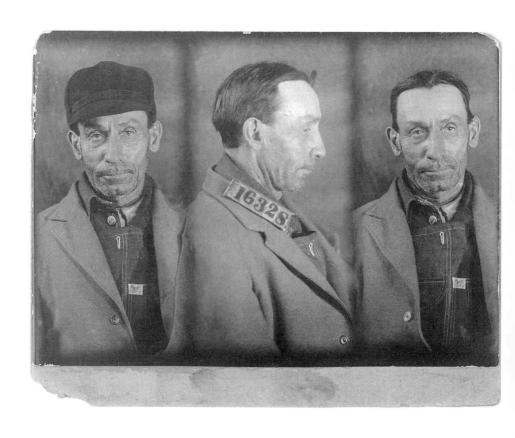

The Heist #5
The Lazybones

Now, Listless had no observable talent for crime. And he had no hidden talent, either. He's a guy you add to your crew to fill it out. By that I mean just to make it look like you've got a bigger gang. A purely for show ego thing. Because the guy has got no get-up-and-go, no pep, no nothing. Somebody said Listless went to a boxing match once, and when the fighters glanced over to where he was sitting they both fell asleep. This was later registered as a double knockout, but the folks who were there say it was Listless's fault for sure. I guess you got to admire a guy who can look at the same expression in the mirror day after day and not end up slitting his own throat. Hey, I bet the boss hired him 'cause ol' Listy married his sister.

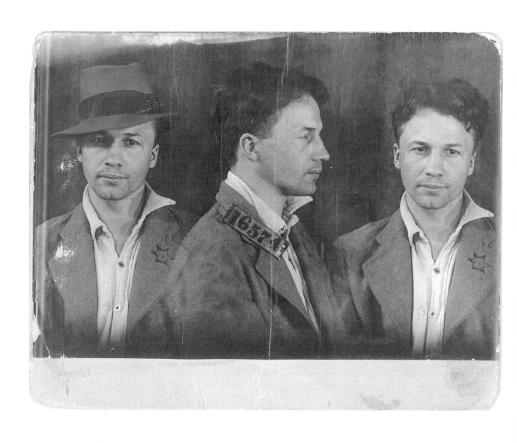

The Heist #6
The Stone Cold Guy

Now, Polk was a guy you didn't want to cross. He was a cold fish with the heart of a shark. (I think I read somewheres that a shark ain't no fish, but just an eatin' machine.) It was rumored that Polk had killed his real ma and pa, his foster parents, and even a couple of folks he'd never met but who had been at the orphanage one day looking to adopt. He murdered his high school sweetheart, too. That came as quite a surprise, since he supposedly told his real ma (while she was still alive) that taking Becky to the prom was the happiest night of his life. And as far as the heist goes, boy did he kill a lot of people unnecessarily. I wonder if he thought of any of them while he was sitting in the chair waiting for them to drop that gas pellet into the bucket?

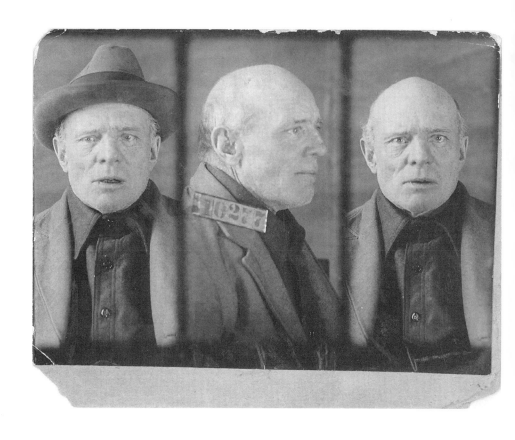

The Heist #7
The Fix-It Guy

Now, I think the boss, in his heart of hearts, knew it was a bad idea to bring Blinky Altum on board. Sure, the guy could do tricks with electrical wire. He knew alarm systems inside and out. But this was a very up-to-the-minute bank with a system made in Germany, which is a very security-minded land, if you haven't checked lately. So when Blinky said that he had taken care of everything, I should have double-checked instead of just taking his word for it. But I think the boss got soft because Blinky was the boss when the boss was just a little stooge stealing baseball cards from the other kids on the block. Blinky was a link to the past. He was tradition. Which didn't count for squat when the alarm went off louder than Times Square on New Year's Eve. Crime and sentiment just don't mix.

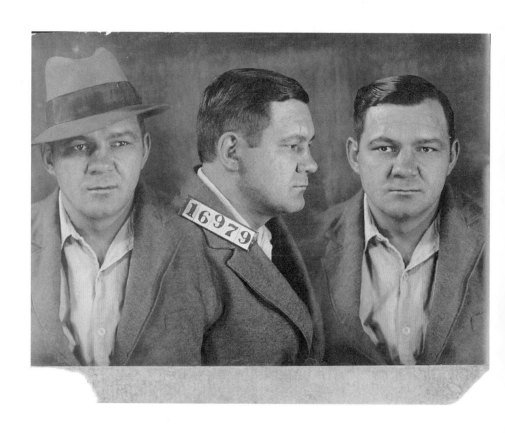

The Heist #8
The Boss

Now, I would have marched into hell for this guy. And I only knew him for a week. He was soft-spoken and considerate. He had a gentle smile and a great laugh. But he was tough as a whip when he had to be. He started in the rackets by going from town to town during Yankee road trips and posing as the Great Bambino, Babe Ruth. He'd just charge everything in the Babe's name. He was so good, once he even spent Thanksgiving with Mrs. Ruth. She didn't notice a thing except to say that the Babe was being unusually sweet that evening. It sure was sad when the heist went bust after all his careful planning. Those big teardrops rolling down his cheeks as they tossed us into the paddy wagon couldn't help but remind one of another great man who cried because he had no more worlds to conquer.

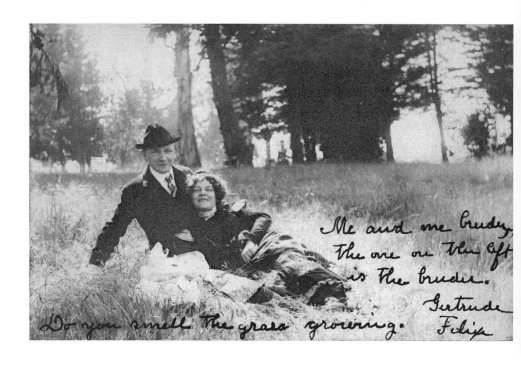

Me and me brudz,
the one on the left
is the bruder.
Gertrude
Filja

Do you smell the grass growing.

Questions

Do you smell the grass growing?

Do you remember who you used to be?

Does the past confuse you more than the future?

How many people can know a secret before it stops being a secret?

How can a baby be perfect and yet grow a little more each day?

How many more times funnier can someone be than someone who is not funny at all?

How old must you be in order to pass up a pile of snow that is perfect packing for a snowball?

Wouldn't adults be happier if they took time out each day to cry and skipped down the street occasionally?

Does your thirst get quenched in the throat or in the stomach?

Are you in love all the times you think you are?

Huh?

Doris

"Hello, I'm your hostess, Doris. Welcome to the Alki Homestead, a bit of old Seattle. If there is any problem with your meal, please let me know. I'm the divorced mother of two, Jaycee and Casey. While I'm at work they stay at my mother-in-law Irene's. I pick them up after my shift, and they are usually asleep, so I slip them into my late-model Datsun, which could use some new shocks. I had to split up with my ex-husband, Tod, because of his drinking problem. I was determined not to go down with that ship. The straw that broke the camel's back was when he sold our TV for booze. When his own mother told me to leave him, I did and pronto. He pays no support, but it's worth it just not to have to deal with his demons as well as my own. Life certainly is not like high school, is it? Have a pleasant meal."

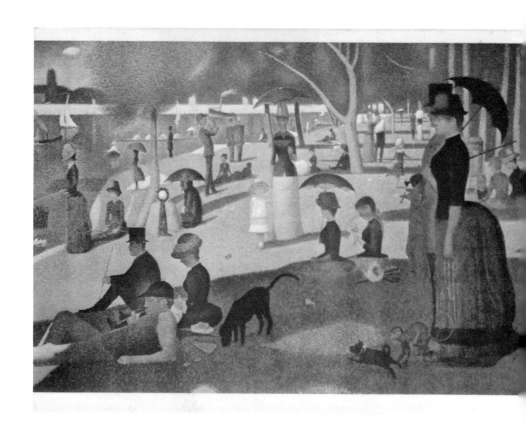

Second Thoughts

What could I have been thinking about? Is that a monkey? Wait a minute, two hundred dots on the bias with a curving motion of sixty degrees shouldn't be a monkey. It should be a little boy. I can't find any little boys in the whole painting. That's what sells. A grandmother sees the painting with a little boy in it and thinks it looks like her grandson and bingo, you've got a sale. You can get meat with your bread for breakfast instead of that God-knows-what that I had this morning. Hell, even if the grandmother doesn't think that it looks like her grandchild, a few more dots usually convinces them that it could be. But who would think that their children's child would look like a monkey? Is that an egg in the sky? It could be a cloud, but all these dots are so confusing. Is that a hand with a baseball? Everyone is carrying an umbrella with only one egg—I mean cloud—in the sky? I must have had umbrellas on the brain that day. If only I could remember where my brushes were, I could paint and not have to get by with this fork.

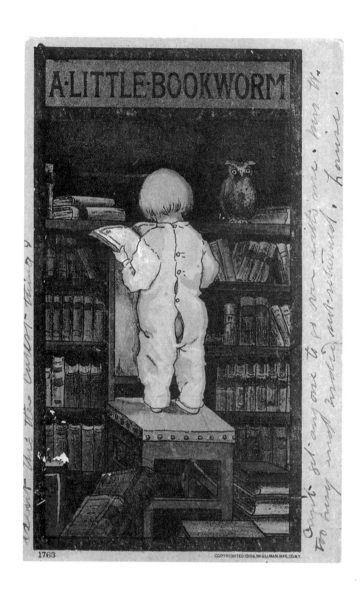

Bookworm

She would sit for hours watching her father read.
Watching as the great panorama of life quietly crossed
his face. The black spots on the page like little matches
that burst into flames in his eyes. She marveled at the
way his eyes would jump across the page in perfect
unison like trained bunnies. Every so often he would
pause to take a sip of tea from a mug with his name on
it. Other times he would chuckle, or he would cluck his
tongue in dismay. Every once in a while he would look
up, smile dreamily, and smooth her hair back. Then he
would dive back into his reading. There they would
remain for hours surrounded by the warmth of the
countless books as the day faded away like the strains
of a popular song.

The Metcalfs

Conrad took people at their word. If they said they'd do something, they were supposed to do it. He had his heart broken often by mechanics and younger brothers.

Marge sat up past midnight two or three times a week, leafing through her high school yearbook while Conrad snoozed beside her.

Nettie was currently working on a very pretty sampler that read "The hurrieder I go, the behinder I get."

Oscar traded his top-of-the-line Buick in for a new one every year. He still had all his teeth. And every once in a while he liked to take in a ball game if the park wasn't jammed because of some stupid pennant race.

Ginger was madly in love with a Korean boy. She hoped one day to marry Kim and move to his homeland, where he would take his place as its long-lost prince. Kim's dad sold fish.

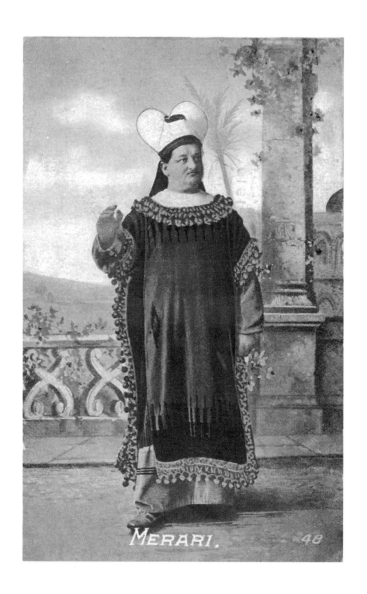

MERARI. 48

Trouble on the Trail to the Land of Milk and Honey

Merari, the youngest son of Levi and the head of the third great division of Levites, during his march through the desert was in big trouble. The nation of Levi was about to continue its endless trek through this hellhole of a desert. Merari was in charge of the tabernacle and the tabernacle was missing. He started looking for it himself, but to no avail. He had thousands under his charge to help him, but how would it look to the other two Levite divisions, who did the heavy work of hunting and warring, if it was found out that he had messed up this cushy but all-important job? Merari went to rouse his wife to help him look. She could be counted on to keep his secret. When he pulled back the covers there was the tabernacle. That did it. He had to really cut back on his drinking from now on. He must have really put away the wine last night.

Some Modest Proposals for Improving the Quality of Life from the Cradle to the Grave

Newborn babies will spend their first days on earth in a toy store, a library, or a bakery instead of a hospital.

Everyone will wear a big "Hello, I'm…" tag from the day that they are born so that nobody ever has to feel embarrassed when they run into people on the street and can't remember their names.

Itchy clothes will be banished.

No ceremony will be allowed if over half the people invited think it's stupid.

Poker will be just as important as getting to work on time.

When you die there will be a festival bigger and more joyous than your best birthday party. Everyone will tell stories about the great times they had with you and the air will be electric with your magic so that you'll never ever really die.

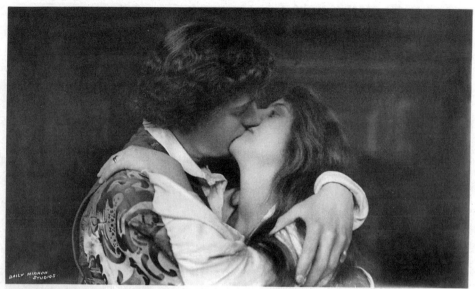

DAILY MIRROR STUDIOS

1212 P

MR. MATHESON LANG & MISS NORA KERIN.
AS "ROMEO." AS "JULIET."

ROTARY PHOTO, E.C.

Juliet

"I fear I'm growing mad. My knees are weak. My heart is aflame. I must use my entire will to support myself, but more than anything I crave to be held by him as if I were a newborn babe. But this is so unprofessional to allow my own emotions to take precedence over the character of Juliet. My god, how long can he hold this kiss? And what does it mean? It matters not. It only matters that I throw my heart, my soul, my life into the character. Could it be that I am such a good actress that I feel love because of my commitment to the idea of Juliet? Could it be that this kiss will never end? No, on both counts, I'm afraid. I don't care. I love him. That's no crime. After rehearsal I must ask Mr. Taylor more about him. He'll know how I should approach him. After all, they seem inseparable."

A Nun's Prayer

Dear Lord, we beseech you:

Give me patience to slowly correct the ignorance of others when they refer to me as a nun instead of a sister or, more properly, Bride of Christ.

Give me the hearing of the lowly jackass, so that I might detect whispers from the back row while I am putting problems on the board.

Give me the eyes of an eagle, so I may spot cheating while I give the weekly spelling quiz.

Grant me the nose of a bloodhound, so I may detect any chewing of grape gum or Nerds, especially during the celebration of Your most Holy Mass.

Allow me the strength of Your prophet Samson when I bring the ruler down on disobedient fingers.

Give me the poise to ignore the prepubescent snickers when we discuss the Intercourse Act of 1719.

For these and all other favors I give thanks. Amen.

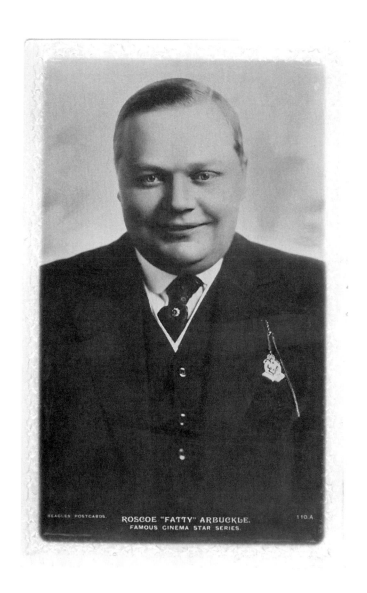

BEAGLES POSTCARDS. ROSCOE "FATTY" ARBUCKLE. 110.A
FAMOUS CINEMA STAR SERIES.

What O.J. Probably Doesn't Know or Remember

A long time ago in Hollywood there was a big star named Roscoe Arbuckle. He made his fame under the name "Fatty." He had a really terrific career. He was a big star before people like Buster Keaton and Chaplin. I think those two acclaimed geniuses even started as bit players in his movies. For sure Keaton did.

Fatty Arbuckle had it all. The big house, yacht, fancy cars, recognition on the street, and of course the reason every man gets involved in show business—girls, girls, girls. More than making movies, however, Fatty liked all the good things that came with it. He liked to relax (only in Hollywood do people have to ensure themselves leisure time from jobs that anyone else would kill for) with wild parties. A lot of people would like that, but few are given the opportunity. But wild parties have a price. There is always danger lurking by. Disaster shadows a wild party. Tragedy is a heartbeat away. And so it was that the fabled drunken bacchanal happened. Virginia Rapp dies legendarily from a Coke bottle. Fatty Arbuckle is charged with murder. His career is ruined. He's washed up and passes through the rest of his days like a ghost. But what a lot of people forget is that he wasn't convicted. He was declared not guilty. Perhaps that was in the days of shame. Perhaps now its different. Maybe public opinion won't destroy O.J. We'll see. The future approaches like a hammer.

Don't

Don't climb into the crib and wake up your brother.

Don't lift up your brother by his head.

Don't play with the Play-Doh anywhere but at the kitchen table.

Don't say "shut up" to anybody, especially a grown-up, especially Mommy or Daddy.

Don't carry water from the bathroom to your bed-room.

Don't run around in the front driveway.

Don't leave your Barbie accessories around for your brother to choke on.

Don't lie down while you're eating, even if it's just a cookie.

Don't jump off the top of the chair, especially if you don't put a pillow to land on first.

Don't...spill that.

Don't dawdle.

Don't; just don't.

94

The Agony of Lower Billing

"Look at them out there, singing and talking and playing
the ukulele and the uk-banjo. Geez, can you believe
him? Throwing his bulk hither and thither and having
the chutzpah to call it dancing. And calling himself 'That
Big Boy'! Actually making money out of the fact that
every night after the show he stuffs himself fuller than a
polka party kielbasa. Like every day is Thanksgiving.
And for the record he's not a Big Boy, he's a *fat man*.
But at least he's a genuine lardo; that smile she sports is
just so much paint, like a cheap Japanese baby doll. If
you could see it from the stage, like me, it would make
your blood run cold. She's got the eyes of a viper, and a
heart to match. I'm the only real talent in the family,
and I only come on for three minutes during one of
their unending costume changes. And that only because
tenors are "in" this year. If my voice ever changes, they'll
probably ditch me in Altoona. Hand me five bucks, one
of his outdated suits, and a 'Don't forget to drop us a
line, Junior.' Bud. Hah!"

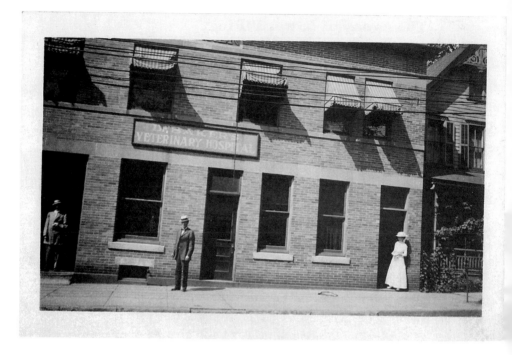

The Two-Man Gal

Esther was in a pickle. She was having an affair of the heart with two men and had mistakenly arranged to meet them both at the same time. She thought she had told Phil to meet her in front of the *veteran's* hospital.... She was amazed she hadn't made this mistake sooner. She had to keep the times and places of their dates in her head for fear that if she wrote them down one or the other would find out. She knew she was wrong in not choosing who to give her heart to, but she did love them and didn't want to hurt their feelings. How could she choose sweet Philo over manly Gus, or vice versa? She knew she should leave the shadows and have it out with them, but she just couldn't face the awkward situation. So with a sigh she went home to her husband.

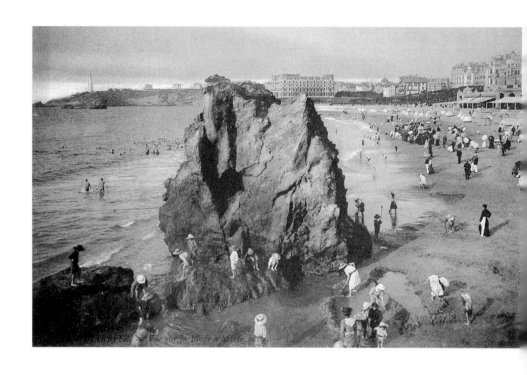

BIARRITZ. — Vue sur la Plage à Marée basse. — LL.

98

The Enormous Sand Castle at Biarritz

Everyone was so proud on that simply perfect day. The kids were off on a field trip to the beach. After lunch Mr. Braine suggested that they build sand castles. The kids decided to make one big castle rather than a bunch of piddly ones. Mr. Braine praised their group spirit. They labored furiously all day. Some worked long after sunset. Many had to be dragged home. All were sad that their beautiful creation would be devoured that night by the hungry sea. But the next day it was still there. And the next and the next. It was not to be budged. Everyone cheered at the miracle…until it proved to be impossible to navigate around, thus ruining the economy of Biarritz and turning the formerly bustling port into a ghost town. Solid, hardworking people became beggars. Mr. Braine was tarred and feathered. But, heck, the kids love it!

MAKE THIS PLEDGE:

I pay no more than top legal prices

I accept no rationed goods
without giving up ration stamps

The American Pledge

I will pass the buck.

I will be nice to minorities to their face, but trash them as soon as they are out of earshot.

I will complain about tax loopholes while eagerly looking for more of my own.

I will root for the underdog unless I have money on the game.

I will cheerfully give directions to out-of-towners, even if I have no idea of where they want to go.

I will give every bit of cliché advice I know to an expectant mother, the stupider the better. If possible, I will come up with a new statistic that is truly frightening.

I will drive as if I own the road and will yell loudest when I'm wrongest.

I will tailgate.

I will end any discussion I seem to be losing with the phrase, "Well, then, how would you like a punch in the mouth."

I will watch more hours of TV than I work, and at work I will spend most of that time making personal phone calls.

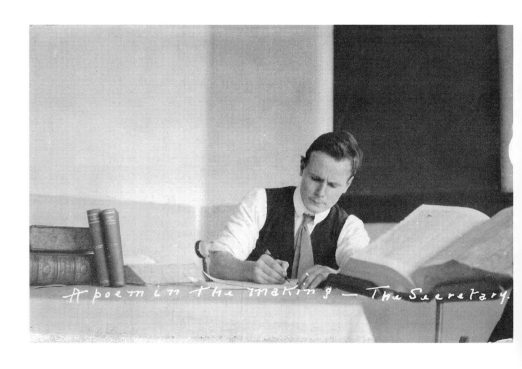

A poem in the making — The Secretary.

A Poem in the Making

A drop of dew slides down a late-summer rose.

An old man grunts softly as he leans over to pick his newspaper off the front stoop.

High above the shouts of all the other children on the playground comes the name "Luigi!"

A flush blossoms over the flesh of a bright young man as his boss steals his best idea.

The American flag snaps in the wind on the most beautiful day in history.

An ugly little man with huge muscles pours tar on the roof as the wind tars his naked torso with dark sweat.

A baby takes a step and a half, tumbles, and on the shakiest legs gets up and tries again.

The clock strikes midnight.

A trapped fly flies out the door.

A little boy with hair like a sunset runs laughing into the soft, soft arms of his mother.

Boys Town's Father Flanagan

No Bad Boys

"No, there's no such thing as a bad boy. I've seen thousands of these youngsters in one form of trouble or the other over the years, but that doesn't mean they're bad. A few, one might even say—most—have at least streaks of naughtiness. For instance, the boys who stole my fatherly garb one day shortly before my important appointment with the cardinal and left me nothing to wear but the Satan costume hat I wore as a joke one Halloween—they could certainly be called high-spirited. And the lads who used fire hoses to break up the parade in honor of our visiting pontiff might be characterized as wild. Truth to tell, I would also have to say that the young and at the moment still at-large hooligans who burned down the orphans' rec room probably have mob connections. But truly bad boys? No."

What People Did Before There Were Movies

Had long talks as they looked at the moon.

Went on picnics with homemade foods they unwrapped from thick cloths. Like Christmas presents in the middle of the summer.

Played complex games of charades.

Had quilting bees, barn dances, and even house-raisings where the whole community got together and helped out one of the neighbors who was in need, just because that was the neighborly thing to do.

Played board games, running games, jumping games and just about any game under the sun you could think of. Then they thought up new games.

Invented.

Discovered.

Prayed.

Talked to their children about God, country, and honor.

Noodled around with bits of curved paper, drawings, and light until they invented what we now call movies.

Scotsmen

"We've always said that the test of a true Scotsman was how hard he could squeeze a penny."

"Aye, laddie, 'tis true."

"Before I [shudders] spent mine, I used it as a tiny little paperweight for months on end."

"I kept the coin in my pocket and rolled it from finger to finger every chance I got. As a result my hand got so strong I could crack a walnut with my little finger."

"I invented a little hockey game using the penny as a puck and bits of trash to build a very serviceable arena. When after two years I tired of the game and Lincoln's face had been nearly worn off, I burned the paper arena so that it gave me heat for an entire evening and used the penny to replace one of the fuses in my house."

"When my pension money ran out I spent the penny on food."

"Ptah! And you call yourself a Scotsman."

How Not to Take Medicine

At the first sight of the offending liquid (but beware, the indignity also comes in many other forms, so take heed of any substance that is about to be forced into your body unless the jar has a picture of a very darling baby on the side), stiffen the body from head to foot in order to show the mediciner that you, the medicinee, are not going to take this abuse without a fight. Many times this maneuver alone will so dishearten the opposition that they will give up immediately. Should they proceed, clamp the lips tightly to one another. Holding the image of a pit bull firmly in mind is often helpful. Push the spoon, dropper, or whatever away as hard as possible. Quickly, twist the head, squirming vigorously as you do. Blow or cough the offending junk out with twice the thrust of the attacker. Good luck!

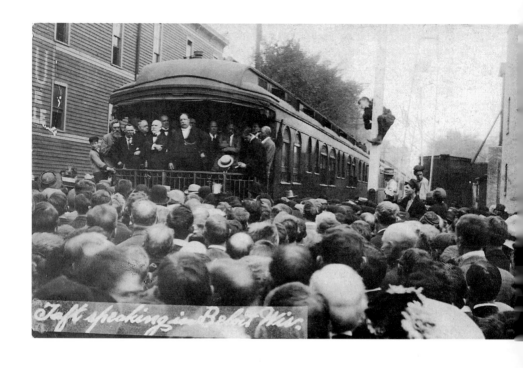

Taft speaking in Beloit Wis.

The Speech

My fellow Americans, I come to you today to speak of the trying times in which we live. We have come to a crossroads in this great land. Which fork will we take? Where will we put the sweat of our brow? The blood of our blood? The treasure of our children? Shall we continue on the path that leads to old ways? Backward thinking? Backward looking? Backward living? Or shall we gird our loins and head down the Path of Change? The path of truth and enlightenment. The way of the future. The hope of our children. Change is frightening, yes. But to whom? I know whom. You know whom. And those who need be afraid know whom also. It is the special interests. The corrupt. The fat cat bureaucrat who is set in his ways and who will fight with his last breath any attempt to bring new ways of doing and thinking into his bailiwick. And why not? Change is no friend to him! Or to his friends in smoky rooms. Or to his relatives with their cushy jobs. They control you if you let the status quo remain. But if, like me, you are tired of paying higher taxes to them; if, like me, you are weary of rising prices and falling wages; if, like me, you wish to throw the rascals out and the devil take the hindmost, join with me now on the crusade for honesty, justice, and peace. Even if we fail, the angels will smile upon us. And our children's children will keep us in their prayers. God bless America.

Speech good for 200 years, minimum.

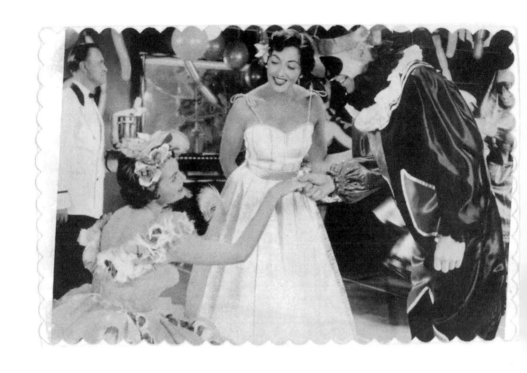

Masquerade

"Clarissa Beaumont, this is Reginald Hunnicutt, lawyer, adventurer, and perhaps the most eligible bachelor in Newport. Reggie, Clarissa is co-chairperson of tonight's do and last year was voted 'Girl the Boys Were Most Mad For.'"

"I'm charmed to meet you, Reginald."

"And I, you, Clarissa. I'd be forever in your debt if you'd be my partner for the next dance. And if the dance seemed adequate to you, perhaps we could steal away later for a candle-lit midnight supper aboard my sloop, *Dancer O'er the Waves*. And if we hit it off, which I'm certain we would, we could fly to Rio and be married as the Brazilian sky turned pink with dawn. We'd have three kids: two boys and a girl. We'd be known as America's greatest family. Grow old and die in each other's arms."

"I'm sorry. I don't dance."

"Oh.... Punch, then?"

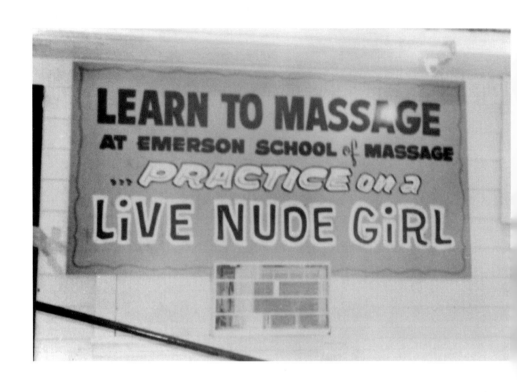

The Massage Lesson

"And here we have our lovely virgin, Chantal…. Oh, for chrissakes, Chantal, go wash your feet…."

"I forgot my slippers and I had to go to the bathroom. It wouldn't kill you, Buzz, to mop in here once in a while…."

"She'll merely be a second, and then she'll initiate you into the ancient art of sensual massage."

"Yeah, except you can't touch my back, shoulders, or knees. I fell asleep on the beach and got sunburnt. And instead of Love Oil, can we use Solarcaine?"

"Oh, Christ, where's Allura?"

"Be here in a second, but don't bug her. She's on the rag 'cause she's got the flu."

"Fine, then, if you'll just wait in our comfortable lounge for a moment. As soon as Allura arrives we'll resume our lesson with a live nude girl."

"Hey, Buzz, is that a shot?"

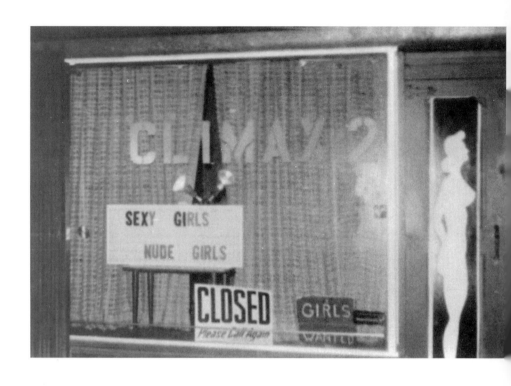

The Job Interview

"Okay, first off, you got any known diseases? Before your final confirmation as a Climax 2 Cutie, we'll send you over to Doc Brezniski for a little look-see. If you got a problem, tell me now and save yourself the embarrassment of being blackballed in the massage parlor industry. For the purpose of this orientation session we'll assume you're clean. Now, you got a nice but not great face. So I'm going to put you in the sexy girl category, which means you'll do the massages in a scanty harem girl or Nazi fräulein outfit, whichever isn't being dry cleaned that day. Of course, the nude girls got it easier; they just lie there buck naked and groan at least once every fifteen seconds. Nude girl gets a buck more an hour. Sexy girl gets better tips. Your choice. Either one's a good job."

The Old Customer

"Jerry, how come you never come by no more?"

"Ah, I started feeling older. Like I should start getting myself a wife and kids."

"We can help you with that. We can show you techniques that will get you that wife. Hell, I think Artie's even got a connection going where you can buy a wife. Like from the Philippines or one of those places. But if you do, make sure you specify English-speaking. A buddy of mine just assumed, and so now he's stuck driving her to night school. Pain in the neck. Nice girl, though. Clean and polite...."

"Yeah, well, thanks, but no thanks. I'm sort of looking for someone I can share books with. Discuss stuff. Movies. Plays. And companionship...."

"That's right. You like those Radcliff types. I tell you, they are a big pain in the ass. Never happy with what you're doing, no matter what it is. High maintenance. Family always looking down on you. No gratitude. And they end up spending all your dough on the stupidest stuff, like contact lenses that are a totally different color than what God gave them at birth. If they spent it on a boob job, okay. But when they get one it's usually not business. It's so they can go meet Mr. Right and raid your fortune by taking a ride down the Community Property Freeway."

"Huh. Well, maybe I'll come in for just a little while. Just to take the chill off."

"Smart boy. So, been playing any softball?"

Wrong Turn off a Very Short Hall

"Oops, sorry, sorry, wrong room. Don't let me bother
you. My fault. No problem. Just looking for the sexy
girls. Boy, that light sure is red. But it's a, you know, a
good color for you. Not that I go that way. Well, no, I
haven't tried, but I just know it wouldn't be the thing for
me. Like I knew that I wasn't a brussel sprouts kind of
guy. Or a guy who would enjoy the Tilt-a-Whirl. I
actually went on it once and I got deathly ill, so I was
right. No, no, you don't make me deathly ill. You're very
handsome...or pretty, or however you want to think of
yourself. I just don't happen to swing that way, but I
don't condemn anyone who does. Because this is
America and we're free to do stuff like that. I mean,
after all, isn't that why the Minutemen fought at Valley
Forge? So go ahead, it's hunky-dory with me...just
not with *me*. So, sexy girls to the right? Thanks....
Brrrruuuhhhh!"

A Gift Subscription

to

JUNIOR NATURAL HISTORY MAGAZINE

is

Presented to you with Seasonal Greetings

by

Mrs. B. Cleaves Wolcott

THE AMERICAN MUSEUM OF NATURAL HISTORY

The Birthday Present

Bruce was very excited about his birthday present from his Great Aunt Beatrice. Today he read in the newspaper that she had given over a million dollars to the Natural History Museum. Heck, if she gave away that much money to a dusty old museum just imagine how much she still had left to give to a favorite grandnephew. Cash was always handy, but perhaps a bit crude. Although a large check would fit very nicely in the mail, which is where it would arrive, since the great lady was too fragile to travel much anymore. Still, there were thousands of fantastic presents that could arrive at your doorstep: rare coins, priceless stamps and the always-popular precious gem or two. Bruce saw the postman coming up the walk carrying something postcard-sized. Omigod! It must be a Picasso.

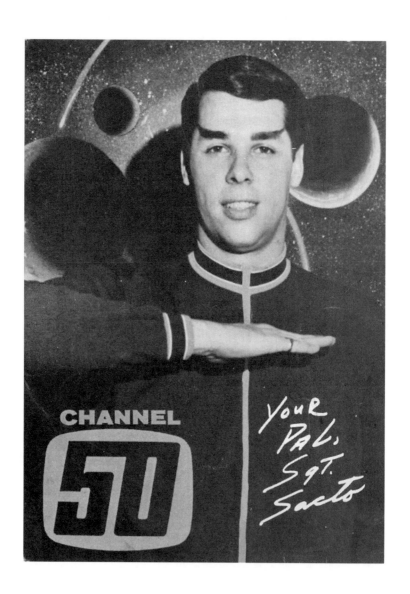

A Letter from Beyond the Moon

Dear Jeff,

On behalf of the entire space crew here at Channel 50, I'd like to thank you for watching. Strange as it may seem, many space cadets your age choose to watch the Uncle Bucky show on Channel 2 or Cartoonerama on Channel 8 instead of our educational yet still exciting and fun show every day. What you realize and they don't is that what's at stake here isn't just the fate of some kids' show but the survival of this planet. An attack is imminent on our space frontier if the Screaming Magic Pods of Isis X-9 believe that they can overpower us because the youth of Earth have stopped watching. Call your friends. Picket the PTA. Do something. The fate of Terra is in your hands!

P.S. No, there are no refunds on the decoder rings.

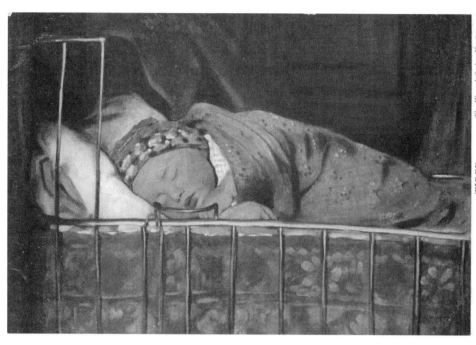

TIRED. The Wrench Series, No. 842.

From "*World's Children*," by Mortimer Menpes, published by A. &C. Black, London, W.

Tired

Her eyes begin to grow a little dim, like the sun catching the edge of a cloud. Soon she begins to rub them as if sleep were a cobweb that you can just brush from her face. She turns into a tiny Jekyll and Hyde, swinging from laughter to tears. Her mood turns grumpy like an old-age pensioner who has been told "Your HMO doesn't cover that." Her eyes grow heavy. She fights it, twisting and turning every which way. Whimpering with small cries of desperation. Up onto a shoulder she's flung. One final moan of anguish as she is abandoned by her two most fun pals on earth. Gentle rocking, rocking, rocking. The world grows soft and warm. She drifts away to a long-ago place where she bobbed among the waves of a pink sea and her mother's voice was a distant murmur.

A Half-Hour Comedy Script as Written by Network Execs

Sonny (or whatever hot, sexy name is on the verge of popularity—call Demographics!), a very attractive blond woman with a large bosom and a great sense of comedy timing (all things being relative, of course) enters the room. She is intelligent, bright, sexy, with lots of energy. She wants to help everyone she comes in contact with. She is strong and not afraid of a challenge. Somehow none of this turns off men, but instead makes her more attractive to them. She has a hip job in New York (or whatever is the hottest city to be working in according to the latest *Business Week*). She has lots of friends and is a real winner. Every man in America wants to cuddle her (or more). Every woman wants to be her (think Mary Tyler Moore or Jennifer Aniston of the hit TV show "Friends").

—Sonny

Noun verb adjective hip reference. (Coy smile.) Similar dialog to the end of show (call Research!).

MURDERER.

One **Joe Prater**, on the night of Jan. 10th, 1897, killed C C. Craig. at St. Paul, Ark. Said Prater is about 21 or 22 years old; about 5 feet 10 inches high, weight. about 150 lbs.; dark brown or black hair; small dark mustache; complection dark, and dark freckles; is stoop-shouldered. and has a downward look- can't look a person in the face at all, and generally goes with both hand in his pants pockets.

$125 reward is offered for his capture and delivery to me.

For particular, address,

W. H. WHITTMORE,
ST. PAUL, ARK.

Posture

"Stand up straight and look me in the eye, mister. Are you listening, Joseph Ardmore Prater? Hands out of your pockets, stop slouching, and pay attention. Don't stare at the floor, Mr. Rebellion. The floor isn't talking to you, I am. You had better open your ears and let this all sink in, or someday it won't be your mother who's lecturing you. It will be a judge somewhere, and I'll be rolling over in my grave as they put you in jail forever. Don't lean against the door, the door is for going in and out, it's not a crutch. You're a healthy boy, a little too healthy for your own good sometimes, but your posture is so bad I swear you'd think you had polio, God forbid. Earlier, I had three dimes in my purse and now there are only two. You've got some explaining to do, Mr. Headed for Hades."

Brothers

"Tennyson and I are firmly committed to the idea of becoming partners in business."

"Leopold is drawn toward the dream of opening an automobile dealership so he can use his fast-talking salesman proclivities to con young teenagers or their parents into buying gas-guzzling, over-priced dinosaurs."

"Tennyson finds the idea of an accountancy firm to be more to his liking. It's a bit more time-consuming, but he thinks that by carefully cooking the books of various small companies who had their complete trust in us, we would make slow but steady progress toward enormous estates and around-the-world cruises."

"We have complete faith in our ability and our futures."

"The only thing we are uncertain of, currently, is how to get the answers to tomorrow's geography quiz."

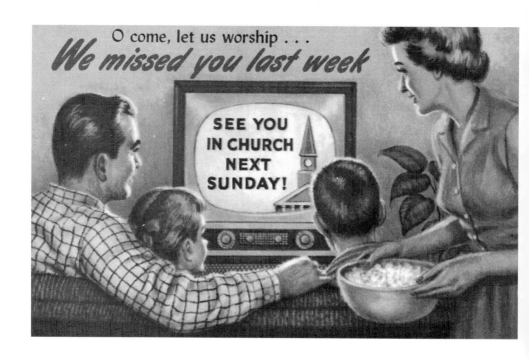

What's Wrong with This Picture?

ANSWER #1: The mother should be at work.

ANALYSIS: Very contemporary and logical, but this homemaker really is one. She is one of the 1.2% of American women who don't have outside jobs. But guilt from the mere eighty hours a week she spends on her family has her thinking about running a domestic referral service out of her home. She's not on the phone because she just got off, having spent three hours planning the school's fifteenth fundraiser of the year, a water-carnival casino-night chili cook-off.

ANSWER #2: Dad is awake.

ANALYSIS: Contrary to popular belief, fathers are actually conscious an astounding 43% more than they appear to be. Granted, this dad is at the moment using "family togetherness" to snag some of that popcorn, but that is not an error in the picture.

ANSWER #3: There is more than one child in this up-scale family.

ANALYSIS: True, in most cases; but here Dad just didn't wait for his vasectomy to "take."

ANSWER #4: The popcorn is in a bowl and not being served in a micro-wave bag.

ANALYSIS: This mom is retro-nostalgic and made Jiffy Pop. The kids appreciate the recyclable aluminum cooking pan.

ANSWER #5: There's no religious content on TV except on Sunday mornings.

ANALYSIS: Bingo!

It's a Ball

"It's the greatest thing in the world. All you have to do is roll it to your dad, and he gets all excited like you could fly or something. You don't even have to roll it straight or all the way to him. He does all the dirty work. If it goes under the couch or into the other room he chases it. And, unlike Buck, he gives it right back, and there isn't any slobber on it. If you act as if you're going to throw it, his eyes really light up. Just like Buck's. And if you throw it? If you throw it even one inch away from your body (even if it isn't a throw but more of a drop), he gets really, really jazzed. He starts talking to you as the little all-star and pepper pot. Learn to throw early. It's your ticket to ice cream."

1100 Molde Altertavle. (Axel Ender)

Eneret Fot. Kirkhorn, Molde

Just Before Meeting Your Maker

"God wants to see you."

"You're kidding. What about?"

"Didn't say, but He looks ticked."

"Oh, man, what'd I do now?"

"Don't know, but He was not a happy chappy."

"Did He say something?"

"Didn't say a word except, you know, He wants to see you."

"Okay. If He didn't say anything how do you know He's pissed?"

"Oh, yeah, God is real good at hiding His emotions."

"Damn, damn, damn!"

"That'll help."

"Shut up, Gabriel."

"I'm just the messenger. I'm not the one who's in trouble.... If you are in trouble... which I'm pretty sure you are."

"I hate you!"

"That your idea of being angelic?"

"Come on. Help me out here. Give me a clue. I gotta go in prepared."

"Love to help, man, but I am totally out of the loop on this baby. Hey, I could be wrong.... Nah, nah, I'm right."

"Well, whatever, it won't get better by stalling. See you, Gabe."

"Later, man. Hey, hang in there, Luce."

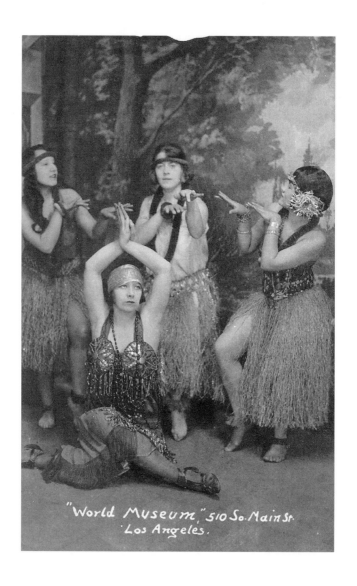

"World Museum," 510 So. Main St.
Los Angeles.

The World Museum Dancers

"All right, ladies, we don't have a lot of time, so let's focus, focus, focus. Now, remember we're all slaves on a faraway island. We were torn from the arms of our warrior-husbands and have been carried off by savage men much more fierce than our own connubial brutes.... What? Well, just give your breastplate to Mrs. Odets, and she'll sew the appropriate amount of feathers and sequins back on. I'm the choreographer, not the seamstress. Nor am I a possible love interest, a father confessor, or a ride home. Now, where were we? Oh, okay, we are sirens of the sea, orphans of a war between bloodthirsty men, who know nothing of love except the vicious mating habits of untamed creatures. Get that fire in your eyes, that jungle rhythm in your feet, and let's dance. Two, three, four."

Spring Recital

<div align="center">

TONIGHT'S PROGRAM

"Iowa: The Great Land of Corn A'Plenty"
—All

"Spring Makes Me Feel Like a Thresher A-Threshing"
—Mrs. Osgood's class, accompanied by Mrs. Phelps

"There's Only One America
(And We Live Smack in the Middle)"
—Mrs. Haber's class (a cappella)

"Lemuel, the Cockeyed Mule"
—The Tettleton Twins

"Grandma's Hands Are Like the Mississippi"
(A Dramatic Presentation)
—Letty Klinkenfield

"The Night the Devil Stepped Out in Old Scarecrow's Clothes"
(A Humorous Diversion)
—Buddy McCormack (costuming by Agnes and Sis M.)

"When the Savior Comes A-Calling, Will He Find You at Home?"
—The Girls' Glee Club

"A Pig Like That You Don't Eat All at Once"
(A very short, comic moment)
—Moochie McCormack

"Barnyard Opry and Hoedown Boogie"
—Boys' and Girls' Glee Club and All
accompanied by The Mighty Music Makers.
Solos by Ettie and Bettie Krempt

NO ONE ADMITTED AFTER CURTAIN GOES UP

</div>

The Betts

Terry Lou won "Homemaker of the Year" three years running and then ran off with a slacker who had a foolproof method of kiting checks.

Linda considered a convent renowned for its vow of silence right up to the novitiate stage and then backed out to make x-rated cakes in a strip mall.

Sally just couldn't keep away from the Cheez-it's, so she ballooned up to 315 and spent her life in front of the TV. Luckily, she and a neighbor won the Lotto.

Bert Alan got catastrophe obsessed and opened a survival store in Upland. It was the right idea at the right time. He now owns seventy-eight of them nationwide, and it is the fastest growing franchise in this great land of ours.

Randy is the star performer and owner of a trained iguana show that has sold out at the Luxor for two and a half years running. He has recently been diagnosed with acute Iguanaitis, which is not life-threatening but is life-inhibiting.

Euphrates (since February her full legal name) is the most popular healer in Taos, New Mexico. She has cured people of everything from brain fever to shingles. Her most amazing feat is ridding Detective Mark Furhman of racism and misogyny. She and Mark live together in a modest house in Chino.

Sara and Bert Betts live in Needles, where he is a systems operator analysis consultant with a specialty in overseas sales. Sara likes to spend time at his side when possible. If not, she may be found in the kitchen.

Arthropoid Man #1:
Notes From the Studio

This week's monster seems to blur the line between
reality and unreality. It's supposed to be an animal and
vegetable combo, right? But, instead of being an ex-
citing amalgam of the two, it's just a mess. The outline
seemed to suggest that it was going to gather strength
from both worlds and give us a greater understanding of
how the other half lives—or, in this case, how the other
half attempts to take over the earth. The costume's
already budgeted, so that's that. But, if we could fortify
the emotional underpinnings of the story, it would help
me out a lot. Then I think the audience will forgive the
more obvious logic problems. With a little luck, they'll
get caught up in the action. If we could ground the
motivations of Hiro, our hero, a little more in reality it
would give the action sequence punch and resonance.
People I talk to like the character very much—or at least
they like the idea of a biology professor who saves the
world each week from coming to an end at the hands of
one monster or another. They are not sure if they like
him for real because often he comes across as intel-
lectual and arrogant. Having him discover his alcoholism
and giving him a handicapped little brother is a good
start. I'd lose the reference to a Möbius strip. I didn't
get it. No one else will.

ゴルゴン星人

Arthropoid Man #2:
More Studio Notes

I think we have an excellent episode going on in "The One Where Hiro Fights Giraffazoids." The lines of good and evil are nicely drawn. You've got one animal you're extraterrestrializing so to speak. The arc of the story is very clear to me. I even think the idea of these peanut-looking guys with the thick skin of a giraffe actually speaks to something in the teen to young adult male. I can see people seeing these archetypes in their lives and being glad that Hiro is blasting them to kingdom come. I have no problem with the story line or the emotional through line or anything like that. I think that, if the bad guys were South African white supremacists doing the same thing instead of Giraffazoids, you might have Emmy potential. The only problem I have is financial. It seems like we're paying for two Giraffazoids, but we don't get the double bang for our creative buck like we should. Either we should differentiate between the two Giraffazoids more or, better yet, make one an off-screen character, say in the mother ship, or something. I think you're going to want the money for more villains come Sweeps time. Unless you think we can hold this episode off until Sweeps. That would be great, but it might put you behind schedule unless you can get the sets of "The One Where a Thousand Really Creepy Larva Fell on the Earth" ready in time. Up to you. It's just a pitch.

ゴルゴン星人

Arthropoid Man #3:
More Studio Notes on the
Giraffazoid Episode

I just got the rough cut of the Giraffazoids episode, and I'm the last person to say "I told you so," but come on. The big climactic battle? The way it's shot where you really can't tell whether it's two of these creatures or not? Okay, what's done is done, but how nice if you could have saved that money for crunch time when the network is going to come hounding you about stunting the show. Getting the girl from "X-Files" or some kind of creature from one of the "Star Trek" spin-offs. Or even one of the rip-offs. At the very least get Rick Baker to design something. Or maybe just give us one of his old castoffs, and we'll say he designed it brand new for us. It won't matter much except to the sci-fi creeps. But they're the ones who kept "X-Files" going during those early lean years. So stay on their good side, and we'll be peaches and cream. My point being that we should try to stay on top of the budget so that, later, not only does it not bite you in the ass, but it can also serve as your ally. As far as specific notes are concerned, I would have to say that my main headline is that when they attack him in tandem, Hiro looks anything but heroic. He looks dorky. He ends up in such an awkward position that it just kind of weirds me out. So get a different angle on that scene, and it will go a long way toward helping me.

シルバー仮面

Arthropoid Man #4:
Focus Groups Notes on
Arthropoid Man

1. The audience would like to see more warm moments between Arthropoid Man and his on-again/off-again girlfriend, Kwan Lee. They are confused as to whether they are friends or "friends." (The greatest boost of all would be if they were more like "Friends," but that is the sort of drastic change in a series that is best decided in a mutual agreement between studio, network, and show runner/creator.) A rescued-from-death-inspired feeling that pushes forward their relationship more into the realm of intimacy would really strengthen matters in this area.

2. The focus group likes the violence/action/good triumphing over evil scenes but would like to see more underlying emotion and character relevance. They would not even mind if Arthropoid Man lost occasionally if it revealed some deep inner human truth that left the audience members (especially men eighteen to thirty-four years old) feeling good about themselves and their lives.

3. Viewers wish they knew more about Arthropoid Man's relationship with the Universatron 2000 XJE. They think it should be more than a hero/information machine thing. They like it when the Universatron calls him Artie. More interpersonal stuff would fly well here. Maybe a high school flashback to show how they met?

4. Limit all the side characters to twenty seconds of screen time or less. If on screen, they should discuss love life of Arthropoid Man and Kwan Lee. This is a must!

5. More "Dawson's Creek" type stories.

A Beautiful Head of Hair

"Everywhere I go, people say the same thing: 'What a beautiful head of hair.' And then they dismiss you from their minds. They've got a way to remember you and something to say if the conversation starts to lull. My uncle won a blue ribbon in canoeing at camp when he was ten years old, and that's the only thing anybody ever said about him after that. He was the canoe champ ever after. Even when he was old and fat and couldn't have moved a canoe with a stick of dynamite. My mom makes the best cheesecake. She never won a prize for it or anything, but everyone is always begging her to make it. So that's how it is with my hair. I've thought about chopping it all off, but then I'd look stupid and probably just be known as the girl who won't eat broccoli."

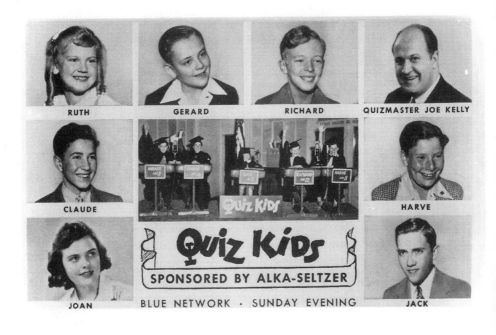

RUTH　　　GERARD　　　RICHARD　　　QUIZMASTER JOE KELLY

CLAUDE　　　HARVE

JOAN　　　JACK

Quiz Kids

SPONSORED BY ALKA-SELTZER

BLUE NETWORK · SUNDAY EVENING

Quiz Kids

Jack would go on to a successful business career cut tragically short by a food stamp scandal.

Harve would wander from one kid show biz venture to the next, finally quitting after his last two disastrous appearances on "Movin' Back in with the Folks" and "Nutty Newlyweds."

Joe Kelly resides in the Home for Indigent M.C.'s.

Richard owns a children's luggage firm, Totes for Tots.

Gerard is the Monsignor of Brussels, though enemies claim he's a spy for Red China.

Ruth has been married six times, has four children out of wedlock, and smokes like a chimney.

Claude is a romance novelist with the pen name Laura Constance. His latest book is *Rapture of Love's Sweet Secret*.

Joan has a lovely garden.

Waldo Felts

He weren't good looking. That is for certain sure. Why, his hair alone was such a moppy mess, ol' Ma Felts would not have been blamed one bit for disowning him. At least from the forehead up. He had a pretty sizable gut on him, like a cat had crawled up inside of his shirt to keep warm. (Though you'd be hard pressed to find a cat with so little self-esteem that he'd hide out in the baggy old rags Waldo would slap on his back. A dog? Well, sure. A dog'll curl hisself up any old wheres. A dog is just a pig with a cheap fur coat.) He had a silly as hell attitude about him that would drive any regular person to distraction just listening to the fooldoddlery that Waldo let fly out of his mouth. He smelled something fierce from the dead carcasses he was always hauling around. (He could shoot. I'll give him that. He once shot the beak off a hummingbird.) But you know what? The girls just could not get enough of him. Why was that?

The New Parent's P.O.V.

They always think that you're going to be President of
the United States. They never picture you behind the
counter of a 7-Eleven or selling office supplies on the
phone or yelling at kids to sit back in their seats while
your head swells like a dirigible of pain. They always see
you marrying the beautiful little redhead who's sleeping
peacefully next to you in the maternity's viewing room.
They never think of you stuck in a totally loveless
situation that you don't have the money or the guts to
get out of. They see your whole life stretching out
before you like a huge, beautiful flower. They can't ever
see you staring into the blackness of your life like a sick
dog. But that's good. That's the way it should be. Their
love is as strong as a mountain and as soft as a lullaby
late at night.

Best Seller

"Sister and I have written our first novel."

"A potential best-seller."

"It's about a young man who works hard, tells the truth, reads the Bible, overcomes adversity, and dies."

"We were going to write a novel about a young girl who stays pure her whole life, fighting off impure events and individuals along the way, but we changed our minds."

"We didn't want to be accused of writing a thinly disguised auto-biography."

"That would've been too easy. Easier than pie, even."

"And pie is the easiest thing in the world for us."

"Our one regret is that we put so much violent death into this book."

"Yes, we would have felt better with one less home invasion or lynching, but our publisher insisted."

"He said it would hurt sales."

Lamp Jumping #1

Dear Blanche,

How are things at agricultural college? Things are fine here. We are a bit sad since we just got back from Aunt Blanche's funeral (whom, as you recall, you are named after). Everyone asked about you, especially Uncle Micklin, who sighed and said, "Well, at least there's one Blanche to still carry on the name." He gave me ten dollars to give to you because, "The other Blanche would have wanted it that way." Then he burst into a torrent of tears. Harder than I ever saw a woman cry. And, as you might remember, I once saw a woman get half her leg ripped off by a combine. A real fancy lawyer read the will. It was lucky she even had one since her death came all sudden like it did. The doctor said that something just popped in her head and killed her brain. Anyway, she left almost everything to her husband , which is natural. But she also included a part that said all of her lamps should go to the Paldren family. Which would be us, of course. Being a lamp collector and all she had a ton of those things. Some of 'em pretty nice, but most are just serviceable. We just stuck 'em in the barn until we can figure out what to do. It sure has been scorching lately.

Your sister, Letty

Lamp Jumping #2

Dear Blanche,

Hope you're having fun at that farm college because it's hot as blue blazes here. Who is this Barton you mentioned in your last letter? He sounds cute. He'd better be. Has he got a brother? Ha ha, just kidding. Nothing much going on here. We got some ducks to get a little variety in the livestock, but one of them got sick. Then they all got sick. And that was pretty much it for the ducks. It was so hot the other day I did a real dumb thing. You know all those lamps we had in the barn? Well, we had to move them out to look for one of the ducks that had died but we couldn't find. You knew he was dead by the smell. But anyway, all the lamps had to be put outside to get the smell of dead duck off of 'em, and I started lining them up in different ways. Then I started jumping over them. It was just funny at first, but then I started getting kind of good at it. Like one of those girls in the circus. (Remember the Thompson twins who ran off to join? They are now the Great Thompsoninis.) Jumping is fun, but it sure makes you sweaty. Write when you can.

Love, Letty

Lamp Jumping #3

Dear Blanche,

You are not going to believe all the goings-on going on at Triple Trouble Corners. There hasn't been this much commotion since the original Triple Trouble (which, by the way, have you ever noticed no one ever talks about? All I know for sure is that it was about 100 years ago, and it involved a mess of bloodshed. I looked it up in the old newspapers in the library, but all mention of it was ripped out. Spooky. I don't know what they're going to do two years from now when it comes time to celebrate the centennial....). Silly me. I write to you about all the excitement and just get lost on a dumb sidetrack. Shoot me when you see me. Anyhow, this lamp jumping thing I was doing in the backyard? Well, somehow it peaks the interest of Brother Thadeus, Sister Mabel, and even Poppa. Before you know it we're all jumping over, under, around, and through these lamps. I know it sounds silly, but it is just the most fun. We can't stop. It's like we're possessed or something. Even after a whole day of plowing we can't wait to get into our bathing apparel for a good tumble. You'll see come Thanksgiving.

Your Somersaulting Sister, Letty

THE PALDREN'S ORIGINAL LAMP JUMPERS

Lamp Jumping #4

Dear Blanche,

Taaa Daaa! (as we say in show biz). I am sorely sorry that I haven't written in a while, but I have been busier than when that plague of locusts blew in. Heck, busier than when we had that bumper crop of tomatoes, and we were up for a fortnight without sleep in order to can them before they rotted on the vine. Remember how many went bad anyway? Well, busier and tireder than that. News may have reached you by now of our success. (It seems to me that Thad sent you a flier announcing our first public appearance at the Triple Trouble Corners Ninety-eighth Annual Cow Tipping and Bake Off.) To make a long story short, a feller from New York City was out looking to buy a farm for some vaudeville people who had struck it big. (They were a family that sang, danced Polynesian style, and set their hair on fire, I believe.) They wanted a place to retire to once all the hubbub over their act had died down. They ended up buying Carleton Euchre's place and then found out how dull the country can be compared to N.Y.C. They sold it two months later, taking quite a bath in the bargain. But anyway, this feller was their agent. He saw us do our "act" and said, "How would you like to play the Great White Way?" We later found exactly what he meant, but even then it sounded better than the back-breaking labor that farm work is. So now we're The Paldrens: Original Lamp Jumpers.

More later, Sister Letty

Lamp Jumping #5

Dear Blanche,

Tonight was the proudest night of Poppa's life. Not that he'd admit it. He's got ice water for blood, so you never know what he's thinking. The farm could have its best year ever, or the barn and half the house could burn down, and he'd barely raise an eyebrow either way. But you can see the fire of lamp jumping in his eyes. I think we've spent half of the money we ever made on pictures of us. He says it's for publicity purposes, but I say it's pure pride. Finally doing something that had never been done in his family before. A lot of people don't remember, but Poppa was the runt of his family. And his father bullied him night and day concerning his failings. How he was gonna muddy the good name of Paldren. So you can imagine how Poppa's face must have looked staring up at the marquee (that's the front part of the theater where your name goes if you have an act). Standing in front of one of the biggest theaters in Los Angeles and seeing "The Four Paldrens." Well, I don't have to imagine because I was there. And even though it was a cloudy night, it looked like his face was bathed in moonlight. His eyes shone like fireflies. After a long silence this stone-faced man turned to me and, with a voice crackling with tears, he said, "Let's go home, then. We got eight shows tomorrow, and we're not getting any sleep standing here."

Proudly, Letty Paldren

Lamp Jumping #6

Dear Blanche,

Well, the frost is certainly off the pumpkin as far as vaudeville is concerned. Lots of cheap hotels and washing out your hose in the sink. Never see much of the towns we play because of six shows a day. Then even if you do get an off day, you're just too dog tired to do any sightseeing. We pretty much travel with the same bunch of back-biting, upstaging, no-talent so-and-so's. Pardon my French. Pa has got himself in an awful fix with the Two Lillies. Both of them lost husbands in a terrible juggling accident early last year, and they are extremely lonely if you get my drift. I myself have been keeping company with the Oxfordoscope. But I'm not sure if I'm prepared to commit my life to a man whose act is showing slides of Oxford and knowing every tiny little detail of the place. It just seems so trendy to me that I'm afraid it won't last. It's not a standard like lamp jumping.

Yours, Letty

Lamp Jumping #7

Dear Blanche,

I hoped for it. I prayed for it. And now it's here. No, no, not our engagement at the Palace, silly. (Although headlining here would be the one and only thing anybody else in show business cares about. I tell you we used to think that those folks at the Grange meeting were shallow. Performers can't even be measured with a ruler in that department.) I'm in love. Glorious, beauteous, fabulous love. His name is Chester O'Dolittle. He is one of the lead tumblers in a comedy-acrobatic act that bills themselves as Terrible Accident. As one review pointed out, "Their name may be terrible, but they are simply great. Make a date. Don't miss them by accident!" And it's true. He is so manly. His shoulders are twice as broad as Thad's. And Thad is no shrimp boat! Their act is low on the billing, but I think they are going places. It's definitely the sort of thing that could play in Europe. No language barrier to knock about comedy. A wedding in Gay Paree?

Love and XXXXXXX, Letty

Lamp Jumping #8

Dear Blanche,

I hate the sun. I hate the stars. I hate our hotel. I hate food. I hate rehearsing. I would even hate lamp jumping but, since that's all I have to occupy my useless mind at the moment, I can't. I was tricked by Chester O'What a Fool He Made of Letty. I worked with him on his act. I showed him some of our audience-pleasing subtleties. I even taught him a little prayer I found in an Italian prayer book from the 1800's that I always use when I'm a bit afraid of some intricacy of jumping. It has never let me down. He took it and gave me a kiss that made me feel like I had just jumped over a lamp that was on the moon. I even bought him a little lamp medallion that I found in a store on Lexington Ave. It was sold to me by the sweetest old woman who told me that she had once performed as a magician's assistant in the Ford Theater two months to the day before Lincoln was shot there. She even had her review, which was only fair to middling, but I made a big deal out of it like it was a rave from the *Times*. I came upon Chester as he was giving a neck rub to Stella of the Stella Trio (Her given name is actually Stella Stella. Isn't that stupid?). I would have forgiven the massage. After all show biz can make one pretty tense. But they were both stitch stark naked at the time. My heart feels like the rug at the Hippodrome. Old and beaten down. Send me a letter full of smiles.

Sadly, Letty

Lamp Jumping #9

Dear Blanche,

We finally played the Winter Gardens here in England. The audience's S.O. should've been our greatest triumph, but the thunderous applause just sounded like the dull thud of the wings of death. Yes, Chester. I'd put him out of my mind. But he showed up half out his mind with grief. (His face looked like our old bloodhound, Tinker, before he went mad, bit that tall girl, and had to be put down.) He wouldn't leave until I promised to be his bride. I agreed after securing a promise of love, honor, and giving up the grape. However, as I went off to the evening shows, he repaired to the Eel & Thistle to celebrate. There he became involved in a furious dispute over whether he did a comedy act with tumbling or a tumbling act with comedy. A brawl ensued. Chester was killed by a blow from a barstool. Please write....

Inconsolably yours, Letty

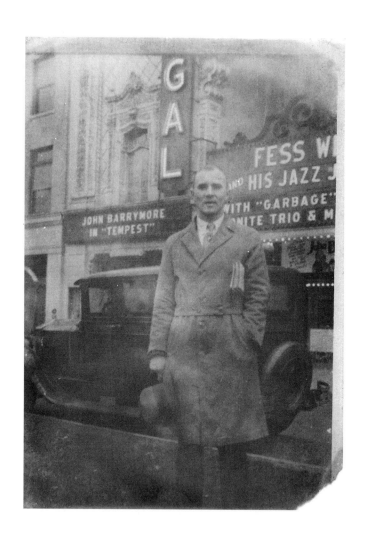

Lamp Jumping (The Finale)

Dear Blanche,

This is just a reminder that I will be bringing Poppa to stay with you through the holidays. I'm afraid he has deteriorated quite a bit since the last time we were together. Last year he would just reminisce about the old lamp jumping days. You know, the great Four Paldren's. And he would know he was just being sentimental. But now I'm afraid his mind has slipped so much into the past that he practically lives there. Wherever he goes he is on the lookout for one theater or another. He insists that I photograph him in front of the marquee so he can send you the snap. He is just so proud of his lamp jumping accomplishments that he can't let go. But now it's really gotten out of hand. The other day at the Regal Theater he got into a fistfight with the manager (a young man of barely shaving age) because they hadn't put our names up yet. I didn't have the heart to tell him our names were never going to go up there again. (I gave the young man two dollars to pretend to apologize for the mishap.) Life hasn't been the same since the demand for lamp jumping faded. It was bound to happen. Hoop running, duck juggling, foot whistling, waterfall singing, tree twirling, and eye spinning. They all had their moment in the sun. Now they're just a vague memory. All anyone wants to see nowadays is flagpole sitting. But mark my words. This too will pass. Poppa's looking forward to that sweater you knitted him.

All my love, Letty

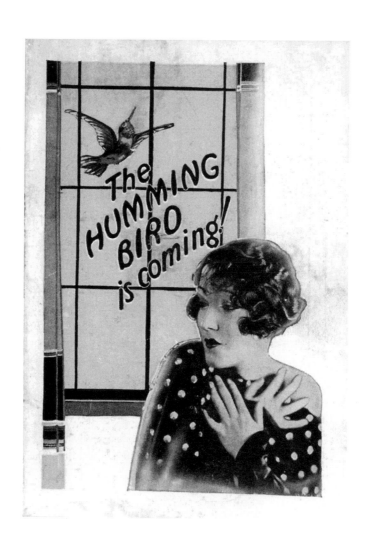

A Conjecture

Now, I'm not exactly sure when it is that Joe Kennedy
had his hotsy-totsy affair with Gloria Swanson. But
consider if you will that it is before he has had that
massive (and soon to be famous) brood of his. The other
parent being, of course, the long-suffering Rose, who at
least gets to outlive the bastard by forty years or so.
What if Joe Kennedy, instead of just fooling around with
Swanson, decides that it is indeed true love? He leaves
Rose. (Probably getting an annulment, no matter how
long the marriage has gone on. The Kennedy men are
very good at this.) Which means no John Kennedy. No
Bobby. No Teddy et al. No total disillusionment on the
part of America's youth following the assassination. No
second assassination. No Chappaquidick. No Camelot.
No John John saluting. No stupid pix of the same ar-
guing with his girlfriend in Central Park. No auctioning
off of Jackie's tacky artifacts. No thousands upon thou-
sands of books, magazine covers, movies, and mini-
series. (Who takes up the slack, the Nixon girls and
David Eisenhower?) Sounds pretty good, doesn't it?
Might even make a decent science fiction novel. Hey,
what if Joe Kennedy, Jr., hadn't been shot down in
World War II?

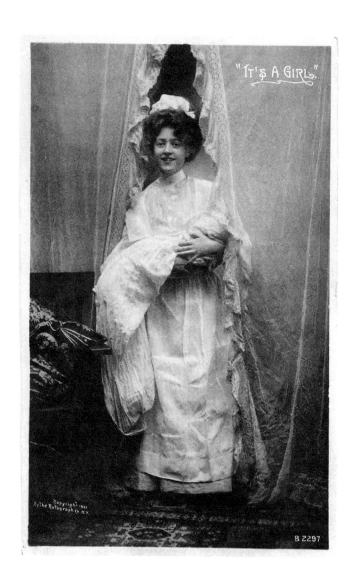

"IT'S A GIRL."

Copyright 1907
By The Rotograph Co. N.Y.

B 2297

Shortly Before the Miracle

She waddled through her day. Like the offspring of a duck and a beached whale. Waddling along with a truckload of blubber preceding her. Whenever she got down on the floor she just didn't know how she was going to get this mass of flesh airborne again. She despaired when she had to do small things that most people consider a snap. Like going upstairs. Her feet were swollen. Her ankles were swollen. Her fingers were like sausages. She could no longer wear her wedding ring. A little thing perhaps, but still it weighed upon her soul. She had heartburn, felt bloated, and her joints hurt. As hard as she tried to stay awake, she seldom made it past "Wheel of Fortune." Often she fell asleep with her glasses on and got startled awake briefly when her husband tried to ease them off. Her body felt out of control. She was miserable. She was fed up. She'd had it up to here.

Then, with a whoosh and a shove and a tug and a burst of joy, the baby was here. And life was perfect.

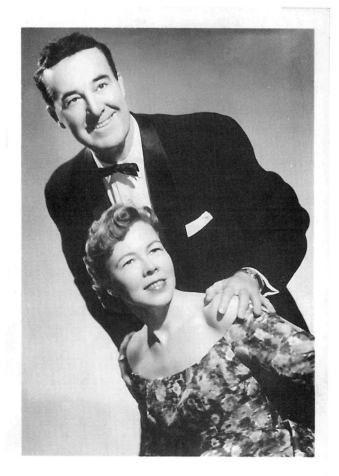

BOB McELROY & CAROL
"MR. AND MRS. ENTERTAINMENT"

Mr. & Mrs. Entertainment Redux

"Well, that's the last of them."

"I can see that, Mrs. Entertainment. I'm not a blind man selling pencils."

"At least a blind man would have more sense than to try and whip the tablecloth out from under tonight's repast after only having read about it in *Today's Magician,* Mr. Entertainment."

"Oh, was I being socially obtuse, or perhaps instead was I trying to divert the attention away from your lip-synch interpretation of Celine and Sinatra duetting 'Something Stupid'?"

"I had to do something once I heard that pathetic puppy-dog-needs-attention tone in your voice as you took everyone's wrap. I knew that they were seconds away from enduring your Donald Duck doing the 'I Have a Dream' speech."

"Oh, let's not bicker before bed."

"Well, we could…you know…."

"Oh, you are a vixen. Together?"

"Of course. I'll dial. You speak."

"Hello? Is your refrigerator running?"

"Well, then, you'd better catch it!"